CW00481689

HARPENDEN
THROUGH TIME
John Cooper

Also by John Cooper

Introduction

During the early part of the twentieth century, countless images of Harpenden were captured on camera by a small but dedicated group of photographers, the numerous pictures taken providing an everlasting legacy of the development from an agricultural village to the lovely commuter town of almost 30,000 people that it is today. Without the photographers' enthusiasm and commitment in recording for posterity mostly everyday views and occurrences, much of Harpenden's pictorial history would have been lost forever.

One of the important by-products of all these images was the picture postcard, a popular and fast means of communication in Edwardian times, where a message sent by the first post in the morning was very often guaranteed to be received the same day. Using a selection of these old postcards, many of which have not seen the light of day for generations, coupled with modern-day photographs to illustrate the many changes that have taken place over the years, the reader is taken on a fascinating journey around the Village, as Harpenden is still known to its older residents. Many photographs were taken of the High Street and the beautiful panorama of the Common, literally the jewel in Harpenden's crown, where the eagerly awaited annual horse races were once held and children paddled in the long gone and much missed Silver Cup pond.

These sepia images also depict Church Green in those halcyon days before the First World War, when the Statty Fair arrived each year in the third week of September to set up their swingboats, roundabouts and hoopla stalls, and more recent events such as the exciting celebrations marking the coronation of King George V. Later pictures show prisoners of war clearing snow from the pavements before their eventual repatriation after the cessation of hostilities.

Travelling up Station Road in the direction of Batford, we branch off along Marquis Lane towards the quaint eighteenth-century riverside inn, the Grade II listed Marquis of Granby, before crossing the River Lea by the ford footbridge. Here we find Batford Mill, one of four watermills in the parish of Wheathampstead, which included Harpenden, and was mentioned in the Domesday Book of 1086. Today, the old mill is enjoying a new renaissance as offices and industrial units.

Another of the interesting aspects of our journey is a visit to the historic village of Wheathampstead, approximately 3 miles from Harpenden, where, by following an informative

heritage trail, various places of interest can be viewed such as Devil's Dyke, the name given to the massive defensive earthwork constructed over 2,000 years ago, the unique Victorian Crinkle Crankle walls and the superb preserved remains of the old railway station, where passenger trains once travelled between Dunstable and Hatfield.

Returning again to Harpenden, although no longer the quiet and peaceful village of yesteryear, it nevertheless exudes its own particular brand of charm and character with its vibrant pubs, cafés and restaurants, chic boutiques and smart shops. Despite the many changes that have taken place as part of continuing progress, the town can be justifiably proud of its heritage for future generations.

Acknowledgements

I am grateful to the following for their kind assistance:

Laurie Akehurst, London Transport Museum; Dawn Child; Christine Field; Barbara Graham; Harpenden Library; Harpenden Town Council; Judges Postcards Limited; Keith Martin; the management and staff of Mint Velvet, Ladies' Fashions; Catherine Owen; Brian Smith, landlord of the Marquis of Gransby; Anne Udell and Bob Wragg.

I am also grateful to Les Casey; Amy Coburn; Diana Parrott and Rosemary Ross of Harpenden & District Local History Society for their helpful and constructive advice, and for giving me the benefit of their local history knowledge.

Special thanks are extended to my wife Betty for her constant support, encouragement and invaluable input, to my son Mark for his continuous IT support, and to my publishers for their kind assistance in producing this publication.

Every effort has been made to contact all copyright holders, and any errors that have occurred are inadvertent. Anyone who has not been contacted is invited to write to the publishers, so that a full acknowledgement may be made in any subsequent edition of this book.

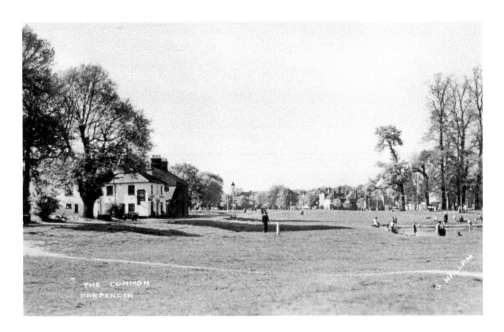

The Silver Cup Coaching Inn

One of the first introductions to the lovely town of Harpenden that the motorist will see as he travels along the normally busy A1081 from St Albans is depicted below. This idyllic view, taken on a sunny summer's day, shows the historic Silver Cup public house, a seventeenth-century coaching inn situated opposite the beautiful Harpenden Common a few hundred yards from the town, arguably one of the most attractive areas in the county, if not the country. Time almost seems to have stood still when compared to the earlier photograph, the only outward difference being the absence of the children's paddling pool on the right, which has long since gone.

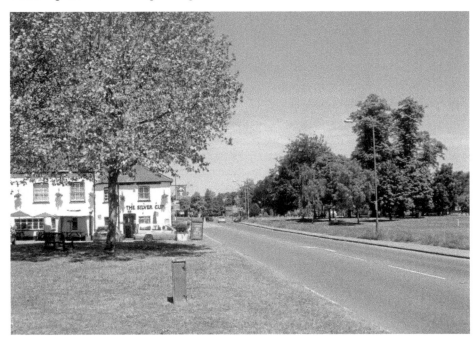

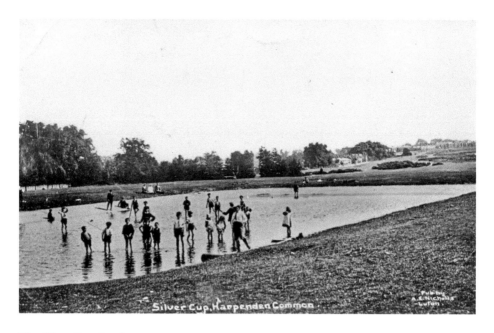

The Silver Cup Pond

The Silver Cup Pond on the Common where generations of youngsters, like those seen above in this early postcard, spent many happy, and probably very wet, hours either paddling or sailing toy yachts. In order to provide a safer and more permanent environment for the countless children who flocked to the water each summer, Sir John Bennet Lawes of Rothamsted Manor had the pond concreted from its natural state in 1899. It remained as a popular venue until 1970 when it was deemed a potential health risk and subsequently filled in and grassed over. It was the end of an era.

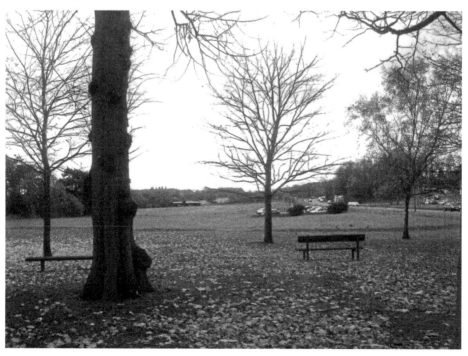

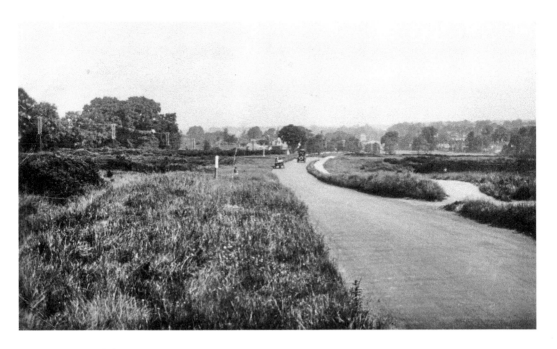

The Top of the Common

This early twentieth-century card postmarked 30 September 1925 was taken at the top of the Common with the scenic panorama of the Village lying in the valley below. Today, a similar photo shot is virtually impossible as a screen of trees, bushes and high shrubs now obliterates the view. However, altering position slightly, the image below pictured in the summer of 2012 shows an attractive part of Southdown nestling among the trees, with the distinctive local landmark of the old water tower in Shakespeare Road on the horizon.

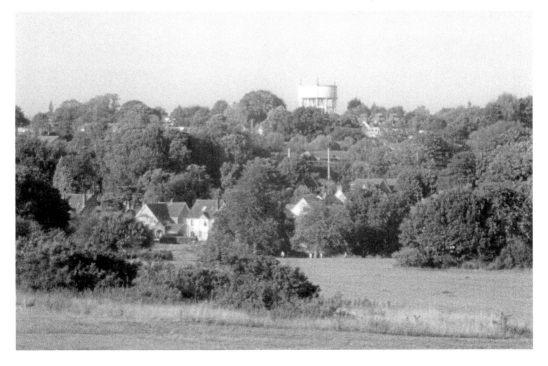

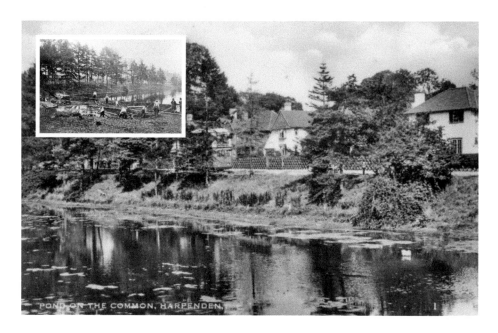

POND ON THE COMMON, HARPENDEN.

'Little Switzerland'

In 1928, the Urban District Council, following a review of its drainage system, decided to fill in the Cock Pond in the High Street and pipe the small stream that flowed along Lower High Street underground to the gravel pits on the Common adjacent to Southdown Road. This necessitated improving the pits, which had originally been dug out in the 1870s, to form three ponds at descending levels to take the storm and surface water from the Village. The project was carried out in around 1929 and provided much needed work for the increasing number of unemployed in the area at that time (*see inset*). Today, this beautiful cool, green oasis, sometimes known as 'Little Switzerland', remains a pleasant place to stroll and linger awhile.

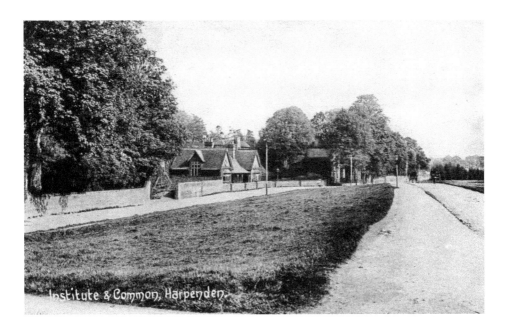

The Institute, Southdown Road

The Institute is seen above on the stretch of Southdown Road that ran from St Dominic's Convent to The Railway Hotel. This section of highway was grassed over in the late 1970s when the new roundabout on Bull Road was completed. During the early part of the First World War, the Institute was utilised as a military hospital, but was only used for a relatively short period of time before the facility was transferred to larger accommodation in Milton Road. Today, the Institute is where the Religious Society of Friends, the Quakers, now hold their meetings.

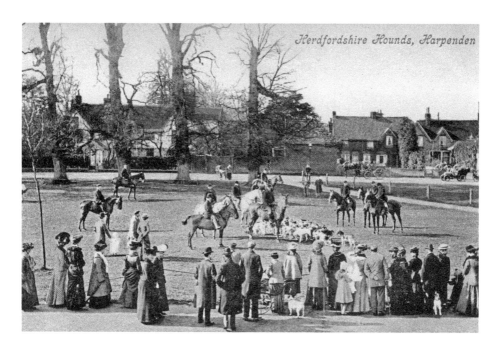

Herdfordshire Hounds, Harpenden

The Hertfordshire Hunt

This delightfully English rural scene, depicted above in the early 1900s, shows a meet of the Hertfordshire Hunt on Harpenden Common. The kennels for the hounds were based at Kinsbourne Green where, each morning and evening, the dogs were taken out and exercised on the Common bordering the kennels. One of the favourite meets was on Boxing Day morning. It must have been quite a sight to see the huntsmen in their white riding breeches and scarlet coats, and the ladies looking elegant sitting side-saddle, setting off at the sound of the horn in the crisp, clear air, the baying hounds eager to pick up the scent of the fox. With the horses and hounds no longer at Kinsbourne Green and the meets but a distant memory, this autumn image of the Common with Leyton Road in the background still gives a feeling of peace and tranquillity.

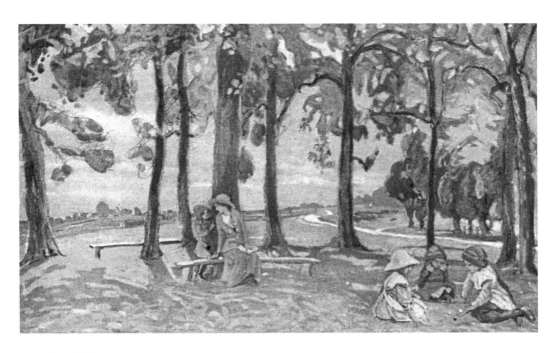

Local Art

One of a number of notable residents who have lived in Harpenden over the years was the renowned artist Alfred Ernest Heasman, who lived in the Village for twenty-two years until his death on 26 July 1927 aged fifty-three. Born on 15 February 1874 in Lindfield, Sussex, Ernest's first job was as a draughtsman for the stained glass artist Charles Kempe. After studying at the Slade School between 1898 and 1901, he later joined the firm of Herbert Bryans as Head Draughtsman before eventually leaving to follow his own design and painting pursuits. It was in Harpenden that these lovely coloured sketches of the Baa Lamb trees on the Common (*above*) and St John's church were produced, among others, in 1914.

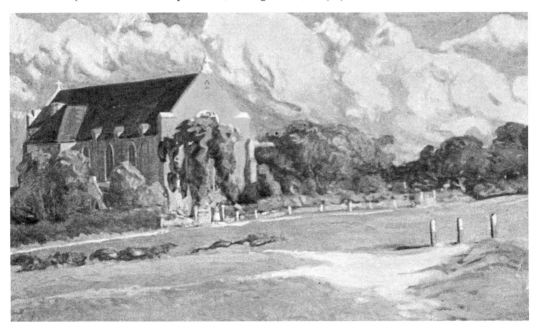

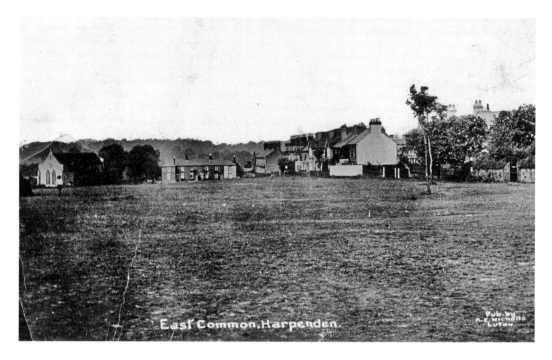

East Common

East Common

East Common as featured on a card posted in 1915 shows the church of St John on the left, with Water's Terrace further along St John's Road. The church, designed by noted architect Mr F. C. Eden, was consecrated on 2 March 1908 and replaced the original structure that had been erected on the corner of Crabtree Lane and Southdown Road. Known as the 'Paper Church', due to its timber-framed construction, the building was completely destroyed by fire on New Year's Eve in 1905, and the site was eventually developed for housing. Just out of camera shot in the modern-day photograph below is the thriving and popular public house The Engineer, which was built by Thomas Missenden sometime between 1862 and 1865 when he died.

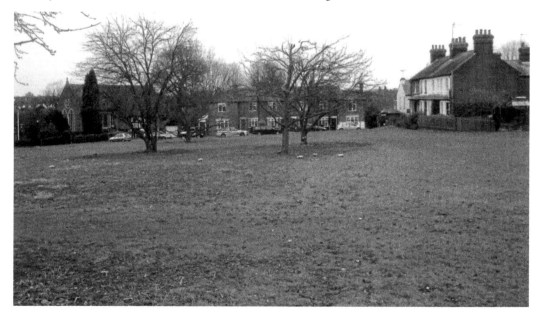

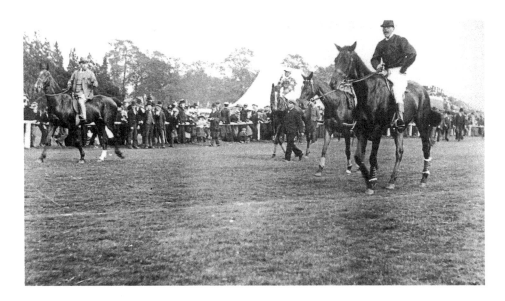

The Harpenden Races

Race Day on the Common was a popular event that attracted large crowds from far and wide including London. Throngs of people poured off the trains and down Station Road in an endless stream. Among the droves of people descending on the Village were the many undesirables, pickpockets, card sharpers and other ruffians who came in search of easy pickings, hence the high police presence that was necessary to control the racegoers and to keep a vigilant watch for any wrongdoings. The horse races were held in May of each year, during the week before the Derby, from 1848 until the outbreak of the First World War. The course, which was in the shape of a long, narrow horseshoe, started on the Common, near to what is now the clubhouse for Harpenden Common Golf Club, and crossed Walkers Road, before sweeping into the country beyond Cross Lane, over the fields of the Childwickbury estate, and turning near Ayres End Lane to return along the Common. Below, is part of the old racecourse today, near to the now defunct Three Horseshoes public house.

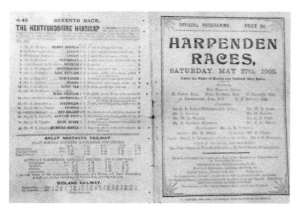

Off to the Races

The enormous crowds arriving at Harpenden station for the annual races were met by rows of horse-drawn waggonettes and brakes for those spectators who were either too lazy to make the long trudge across the Common, or were sufficiently well-off to afford the transport, as seen in the image below. The races were always an important part of the Village calendar and provided a carefree carnival atmosphere, with barrel organs, numerous sideshows, pedlars, coconut shies and Punch and Judy shows to name but a few. However, with so much petty crime taking place, the onlookers had to be constantly on their guard against pickpockets, three-card tricksters and the like. Because so many children took the afternoon off in the early days, the local schools eventually made Race Day an official holiday; even Rothamsted Laboratory closed at noon to allow their staff to enjoy the proceedings.

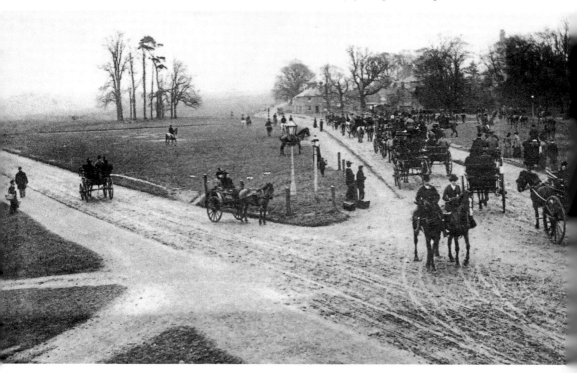

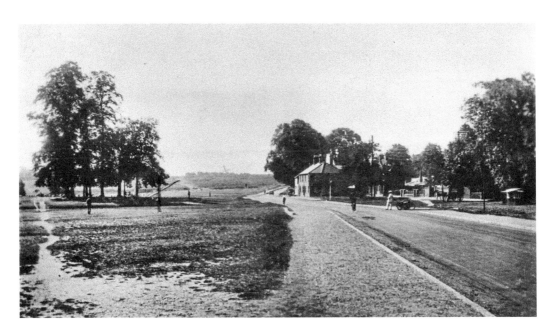

The Common, Looking South

This early 1920s postcard shows the Common, looking south, with the traffic-free A6 stretching into the distance towards St Albans. It shows a vastly different scene from the streams of vehicles normally entering and leaving Harpenden today, although the same view on a winter's morning below looks comparatively quiet, no doubt due to the overnight fall of snow. The well-known local landmark of the Baa Lamb trees is prominent on the left, with the Silver Cup pub in the centre of the picture.

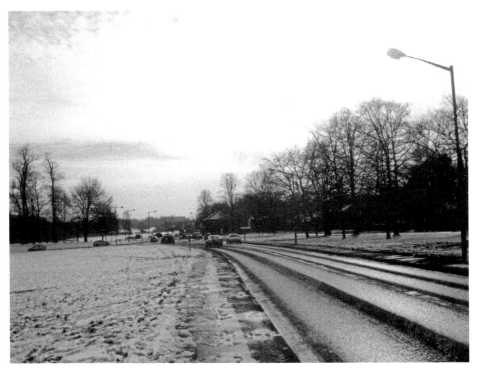

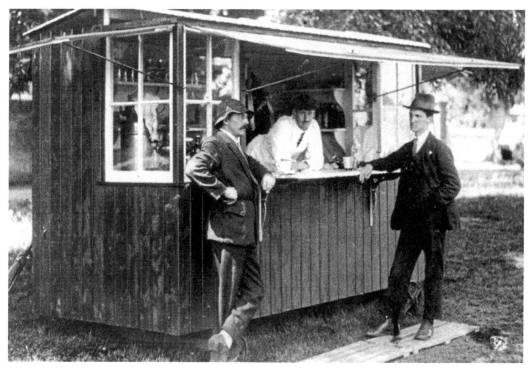

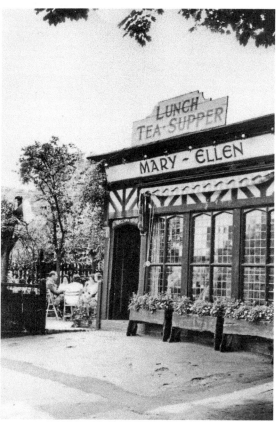

Time for Tea!

Two very different catering establishments in the 1930s were Harry Bennett's coffee stall, which stood next to the Silver Cup cottages on the Common, and Mary-Ellen's tea rooms in Leyton Road, a short distance away. In 1948, with his occupation of the site under threat from the Urban District Council, Harry Bennett organised a petition pleading the case that, because the stall had been open for the duration of the war and this was the only roadside refreshment stall between St Albans and Luton, he should be allowed to remain open. The petition must have been successful as he was still there in the early 1960s. Mary-Ellen's tea rooms opened in 1932 and quickly proved to be a popular rendezvous for its many customers, the speciality being the delicious homemade cakes and scones prepared by the proprietor, Miss Helen Finnie. Miss Finnie, originally from Scotland, retired in 1968 and the premises were then rebuilt, opening in June 1972 as the Inn on the Green.

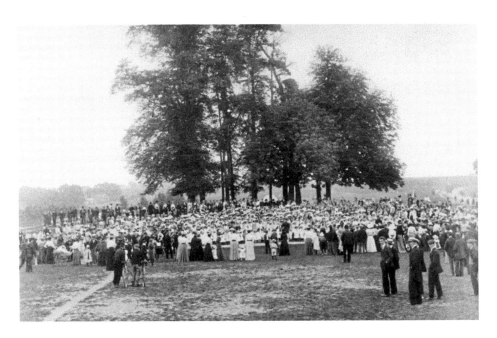

The Baa Lamb Trees

On 9 July 1902, throngs of people gathered on the Common above where a children's fête was held to celebrate the coronation of King Edward VII on 26 June. However, just two days before this spectacular event took place, the king was taken very ill with appendicitis and the festivities were postponed. Following an operation and after making a complete recovery, the king's coronation was rescheduled for 9 August. The fête on Harpenden Common went ahead as planned and included tea, a decorated china mug for each child and organised sports with prizes. With massed singing as well, everyone enjoyed a lovely afternoon. One hundred and ten years later, the same spot on the Triangle in front of the Baa Lamb trees plays host to a completely different type of entertainment, as the pulsating music from the many rides and amusements heralds the start of the annual Statty Fun Fair that arrives on the Common each September.

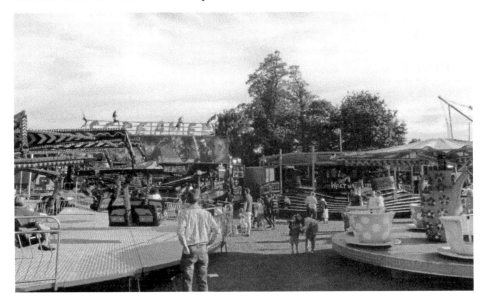

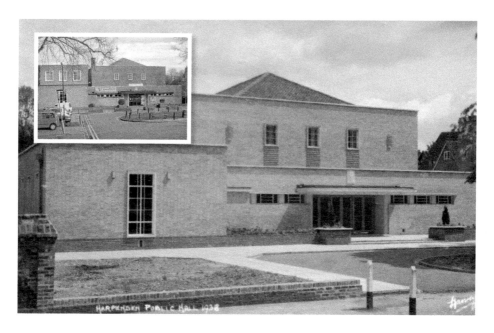

The Public Hall

Since opening its doors in 1938, the Public Hall in Southdown Road has seen a variety of events, from the popular Saturday night dances, where the young people of the day would meet and jitterbug, jive, waltz and quickstep the night away to the strains of George Mason and his band, and the well-known Geoff Stokes band, to the eagerly awaited annual Scout Gang Show, where the highly versatile and very professional participants kept the audience in stitches with their extremely hilarious routines, as seen below. Today, the building is known as the Harpenden Public Halls, and is divided into The Eric Morecambe Hall, named after the famous comedian who lived in the Village from the early 1960s until his untimely death in 1984, and the smaller Southdown Room.

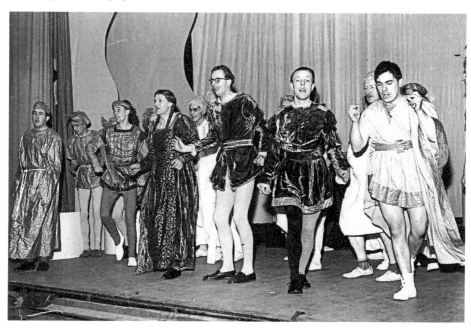

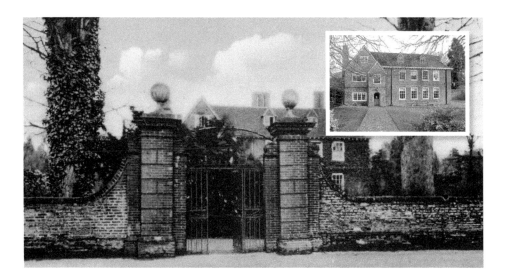

Harpenden Hall

Built in the sixteenth century, Harpenden Hall has seen many changes of occupancy over its long history, including at one time a private lunatic asylum and, more recently, the offices of the Urban District Council. From 1910 until 1923 it was a girls' boarding school catering for twenty pupils and was run by a Miss English. Fees for their residency and education were £35 per term plus an extra five shillings for sporting activities. From 1924 until 1931, the hall was taken over by St Dominic's Convent School, following which they moved the short distance down Southdown Road to their new premises in The Welcombe, once the home of Henry Tylston Hodgson, a local benefactor and the deputy chairman of the Midland Railway. This Grade II listed Georgian building was eventually sold to a hotel group in the 1970s and it is now the Harpenden House Hotel. Harpenden Hall is currently used as office accommodation.

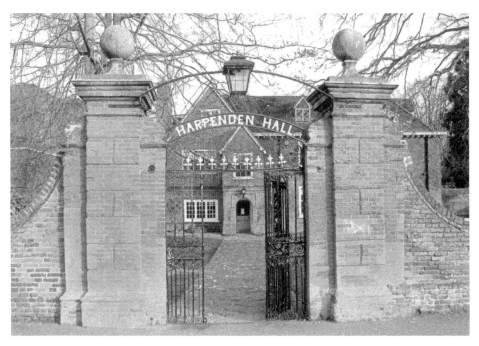

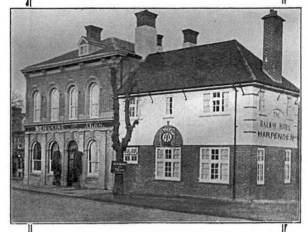

HARPENDEN

The Railway Hotel

High Class Residential

LUNCHEONS and TEAS

Telephone 95 Harpenden

Refurnished by Waring and Gillow

Proprietors—Mr. & Mrs. H. T. SMITH

Recommended A.A. and M.U. Hotel

The Railway Hotel

The Railway Hotel (now The Harpenden Arms) was built around 1870 by James Mardell, the owner of the Peacock Brewery in the High Street, replacing a temporary building that had previously occupied the site serving the men constructing the Midland Railway in the 1860s. In 1890, the landlord was Richard Longland, who, in addition to his hotel commitments, was also the managing director of the Harpenden Gaslight & Coke Company formed in 1864. He also owned the livery stables behind the hotel in Station Road. In 1922, the proprietors of The Railway Hotel were Mr and Mrs Henry Thomas Smith, as indicated in the advertisement on the left that proclaimed the availability of 'High Class Residential Luncheons and Teas'.

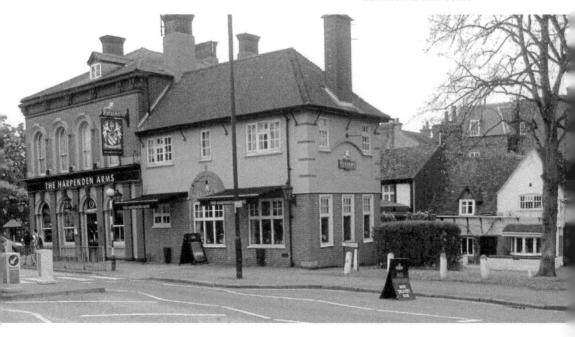

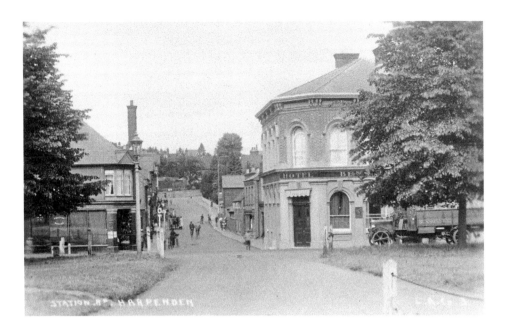

Station Road

This 1920s postcard shows Station Road with Ridleys' ironmongery shop on the left-hand corner, a few years before its acquisition by the Midland Bank in 1933. The Benskins Brewery vehicle on the right of the picture could well have been making a delivery to The Railway Hotel, the large building in the foreground, which is now The Harpenden Arms, a prestigious pub and Thai restaurant. At one stage, The Railway Hotel was the meeting place of the Ancient Order of Foresters, who held an annual grand fête that was one of the most popular events in the Village calendar.

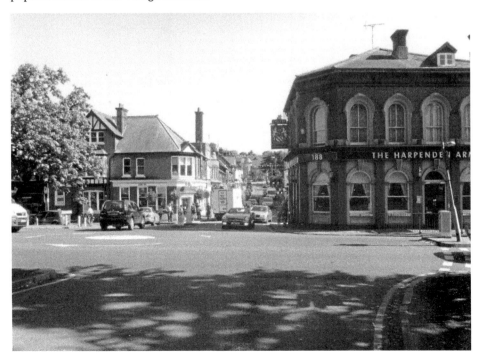

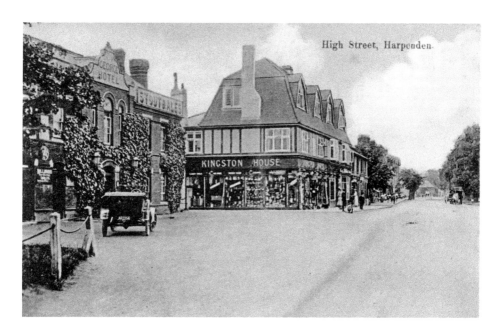

The George Hotel

This tranquil scene from around 1920 shows the forecourt of the ivy-covered George Hotel, complete with a lovely old motor car, Kingston House store in the background and a High Street devoid of any traffic. What a difference when compared to the sunny day in 2012 where lunchtime regulars now sit and relax under parasols over cold drinks. A familiar sight in 1920 would have been that of Mr Hammett, a fishmonger, who travelled each day from Luton by horse and cart to sell his wares from a stall set up in front of The George. He later opened a shop in the High Street.

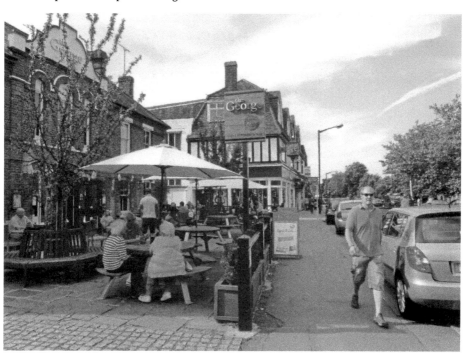

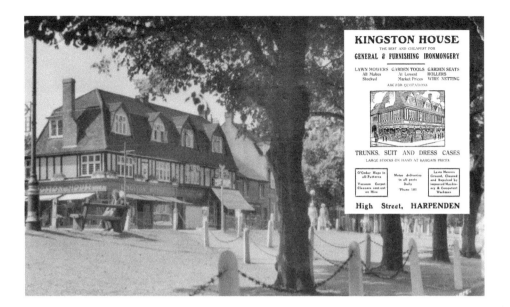

KINGSTON HOUSE
THE BEST AND CHEAPEST FOR

GENERAL & FURNISHING IRONMONGERY

LAWN MOWERS	GARDEN TOOLS	GARDEN SEATS
All Makes	At Lowest	ROLLERS
Stocked	Market Prices	WIRE NETTING

ASK FOR QUOTATIONS

TRUNKS, SUIT AND DRESS CASES
LARGE STOCKS ON HAND AT BARGAIN PRICES

High Street, HARPENDEN

Kingston House

For nearly sixty years during the first half of the twentieth century, one of the most flourishing businesses to trade in Harpenden was that of Kingston House, situated in the High Street next to The George Hotel. Built in 1912 by the firm originally started by Henry Salisbury, the store was constructed on the site of the then recently demolished house that had belonged to Dr Kingston, one of the local doctors. Selling a variety of household goods, Kingston House is probably best remembered for the sale and servicing of its extensive range of lawnmowers. The premises are now part of M&Co., the chain store selling women's, men's and children's clothing.

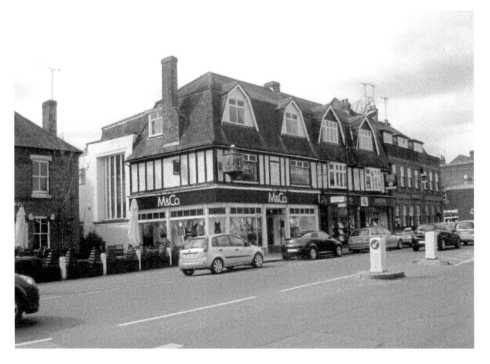

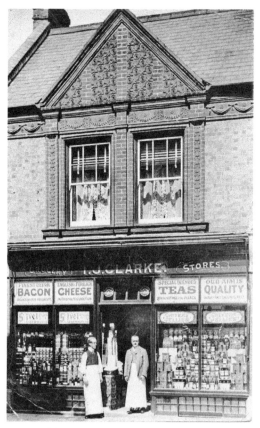

Harriden's Grocery Store

Although built in the 1890s with T. J. Clarke as possibly its first proprietor, the grocery store situated at No. 5 High Street is probably best known as Harriden's after Mr A. J. Harriden, who took over the business in 1922. Many a child growing up in Harpenden between the wars and during the 1950s will remember the delicious aroma of roasting coffee beans that came from a machine in one of the shop windows. The smell was wonderful. Harriden's closed in the 1970s and, although Perry the florist now occupies the premises, the frontage has barely changed in over a hundred years, still maintaining the same wooden double doors and distinctive lattice-work under the windows on either side of the entrance.

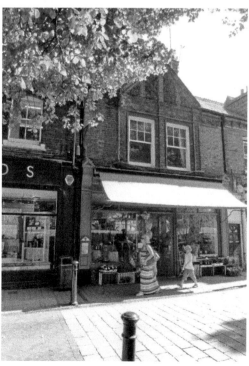

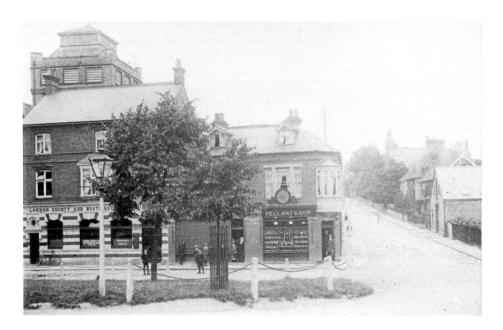

Vaughan Road

This charming old picture postcard, photographed in the early 1900s, shows W. Pellant &
Son, jewellers and watchmakers, on the corner of Vaughan Road and Lower High Street,
with the brewery tower in the background and the London County and Westminster Bank
on the left. This building, with its distinctive brick façade at No. 21 High Street, is still a
bank and now a branch of NatWest. During the 1930s, '40s and '50s, a popular venue in
Harpenden was Bunty's tea room, situated on the opposite corner of Vaughan Road, where
a dainty afternoon tea could be obtained for two shillings. Sadly, the tea room has long
since disappeared and the premises are now occupied by Cancer Research UK.

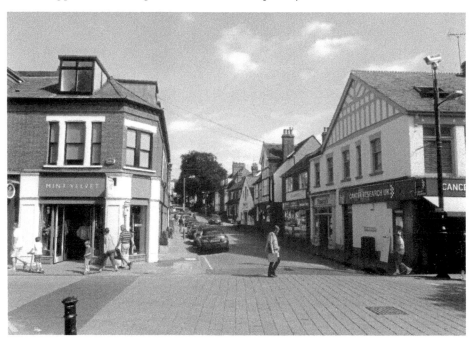

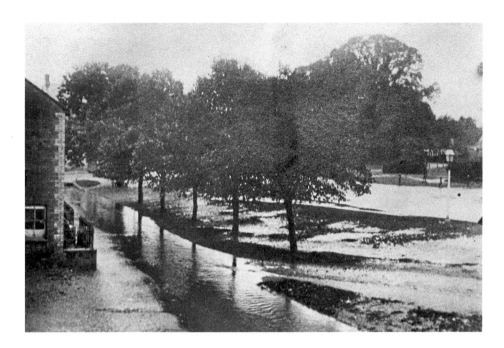

Lower High Street

Taken around the turn of the nineteenth century, this view of Lower High Street on the corner of Vaughan Road shows just how prone the area was to flooding; so much so that the little stream, sometimes grandly referred to as the River Harp, which ran along the High Street was very often quite deep. On one such occasion in 1879, Jack Healey, who owned one of the two breweries in the Village at that time, swam from the Cock Pond to the pond on the Common and back, a feat that so far has supposedly never been repeated. Prior to the First World War, a number of picturesque rustic bridges were installed over the little stream at strategic positions along its length.

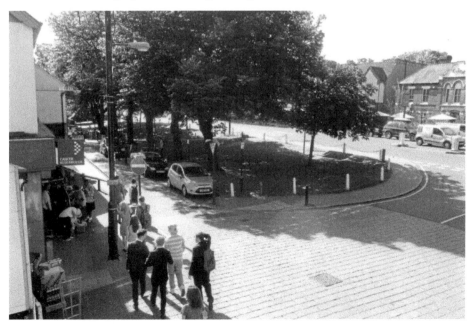

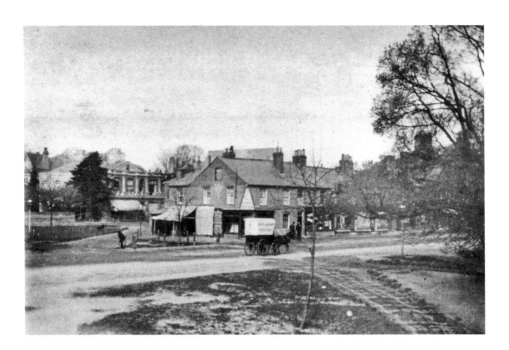

Looking Towards Leyton Road

An early image of the High Street is shown, looking towards Leyton Road, where the emporium of Anscombe's can be seen on the left. During the 1890s, the shop sold a variety of groceries as well as boots, haberdashery and material. Shopping in those distant days was a much more leisurely affair than it is now, when the ladies from the big houses were offered sherry and seed cake before they made their purchases. In the years before the First World War, some of the assistants lived in, having their own bedrooms and a dining room on the top floor. The roof just visible behind the shops in the centre of the picture is the Methodist church, which opened on 26 November 1886.

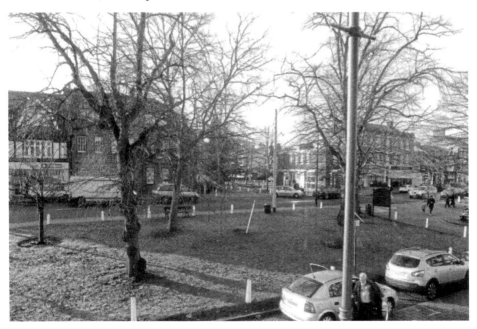

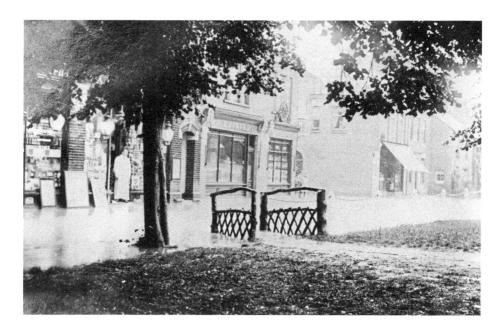

Rustic Bridge

Another charming feature from the early years of the twentieth century were the little rustic bridges that spanned the small stream, which ran from the Cock Pond along Lower High Street. The one pictured above was situated at the junction with Vaughan Road, where the distinctive clock above the jewellery and watchmaking premises of Mr W. Pellant can be seen just behind the bridge with the tailor's shop of Robert Jones next door. With the ever-increasing growth in motor traffic, the pond became very dirty and litter strewn. Eventually, in 1928, it was filled in and the water piped underground to ponds on the Common as part of a comprehensive drainage scheme.

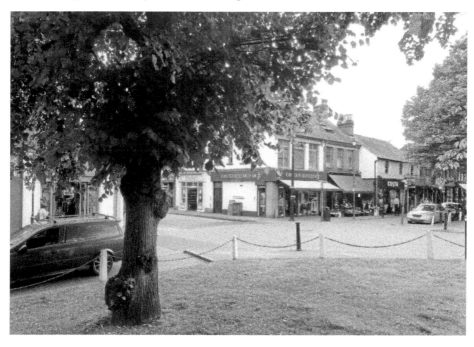

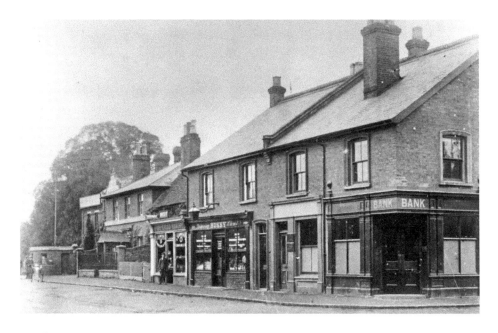

Barclays Corner

In 1887, the year of Queen Victoria's Golden Jubilee, the bank of Marten, Part & Company opened a sub-branch in Harpenden High Street, later known as Barclays Corner. Initially it was only open on Tuesdays and Fridays but with the steady increase in business it extended its opening hours to each weekday, becoming a branch within its own right in 1900. In 1902, it was taken over by Barclays who, in 1923, constructed a new bank to replace the old structure. The small single-storey building on the extreme left of the picture was Cooper's music shop from 1892 until 1898, the *Harpenden Mail* office, a small local weekly paper from 1900 to 1907, and later, in 1920, Chirney's Garage occupied the site. Today, Pizza Express and Caffè Nero carry out their flourishing businesses next to the long-established George public house.

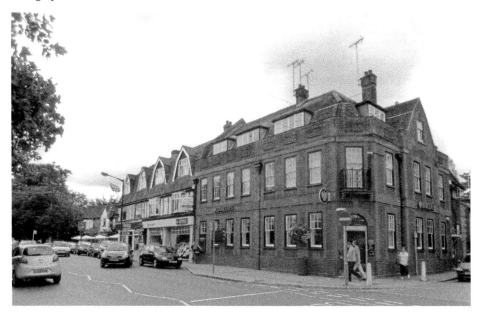

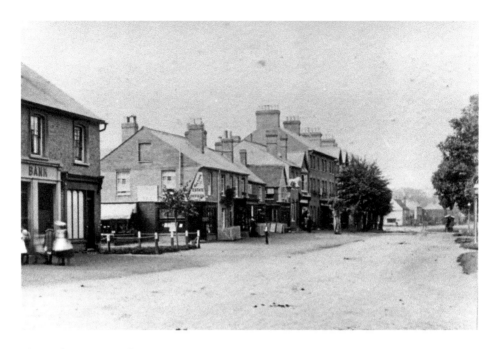

The High Street, Looking North

An early photograph looking north showing a traffic-free High Street in the days before the roads were made up and the pavements laid. Some of the business premises then on this side of the road included: Gibson's, auctioneer's and estate agent's; Herbert Irons, a cabinetmaker who was also an undertaker; and the newsagent and tobacconist's shop of Levi Whitehouse. The distinctive sign of the White Lion public house can also be seen in the centre of the picture, with the white stuccoed façade of the Old Cock Inn just visible beyond the row of trees on the left, which were eventually felled in 1935.

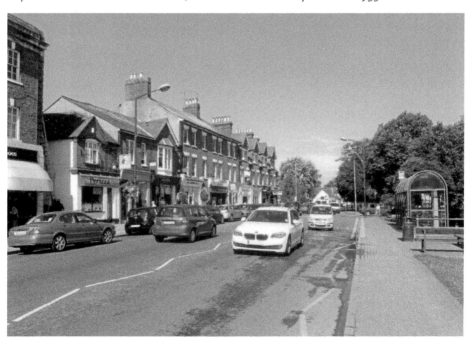

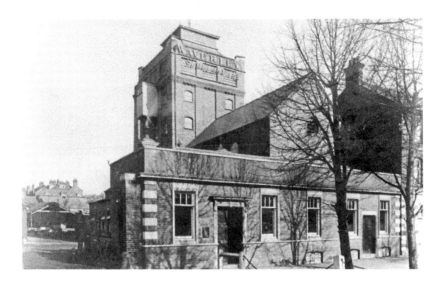

Waverley Mills

During the early 1890s, the two breweries that existed in Harpenden at the time, Mardall's and Healey's in Lower High Street, merged and the amalgamated brewery was subsequently bought by Richard Glover in 1897. The buildings were then modernised and the tower, a local landmark, was erected. A further purchase in 1902 by Prior Reid's of Hatfield made the brewery one of the largest in the county. When the business eventually closed down in 1920, the premises, now renamed Waverley Mills, were taken over by Mr George Bevins who manufactured sportswear, hosiery and knitwear. The firm continued trading for a further sixteen years before the buildings were demolished in 1936 and a Woolworths, Boots and Sainsbury's were constructed on the site. With Woolworths now gone and Sainsbury's operating from further along the High Street, the building recently vacated by Argos is now occupied by the new Public Library. (*Woolworth photograph below copyright Judges Postcards Limited*)

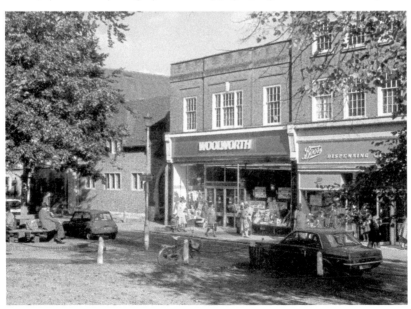

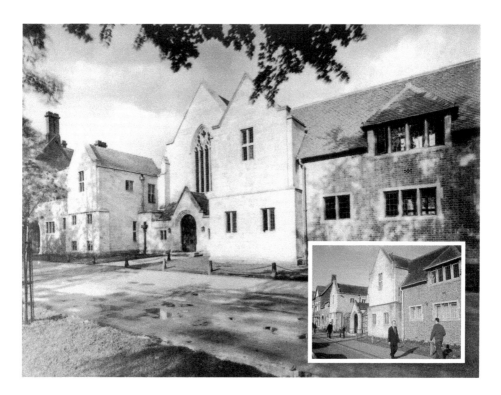

High Street Methodist Church

In 1930, the newly built Methodist church in Lower High Street is depicted here ready for its opening service on 17 September. The building replaced the Wesleyan chapel in Leyton Road, which had been in use since its construction in 1886. The Leyton Road site was subsequently sold and converted into a 333-seater cinema, the Regent, which opened its doors on 26 May 1933. One of the attractions of the church today is Wesley's, a popular coffee shop staffed by a team of dedicated volunteers.

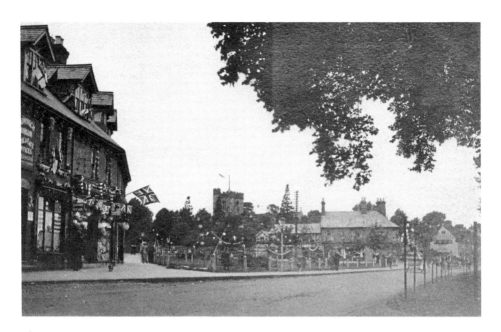

Looking Towards Church Green

Following the death of King Edward VII on 6 May 1910, the coronation of the new King, Prince George, Duke of York, and his Queen, Princess Mary of Teck, took place on Thursday 22 June 1911 at Westminster Abbey. Celebrating like every other town and village in the country, Harpenden festooned its shops, pubs and houses with numerous flags and bunting. With comparatively few people around, the photographer was probably out and about with his camera and tripod fairly early in the day before the crowds had gathered. The view is of Church Green from the High Street, with St Nicholas parish church in the centre of the picture.

The Cross Keys

Photographed in the late 1950s or early 1960s, this charming old pub, the Cross Keys, has served the local community for several hundred years, with the main bar dating back to the sixteenth century. During the 1830s, the landlord was Henry Oldaker who, with his younger brother Robert, had come to live in Harpenden in 1828. Henry was at one time huntsman to the Vale of the White Horse. Despite retiring following a riding accident, he still maintained an interest in anything to do with horses, and in 1848 he organised the first race meeting on the Common, an event that continued until the outbreak of the First World War. Today, the Cross Keys, with its glowing log fire and flagstone floors, extends a warm welcome to its many customers, including some of the members and players of Harpenden Rugby Club.

High Street, Harpenden.

The Village Centre, Looking South

A colour postcard from the 1930s shows the Village centre looking south, with the Cross Keys public house on the left. In 1890, the row of villas seen above was built, occupying the island site between the High Street and Leyton Road, where there had previously been a large house and garden. Originally private homes, the villas, with their distinctive dormer windows, facing Church Green and extending round the corner into the High Street, are today all shops with some flats above.

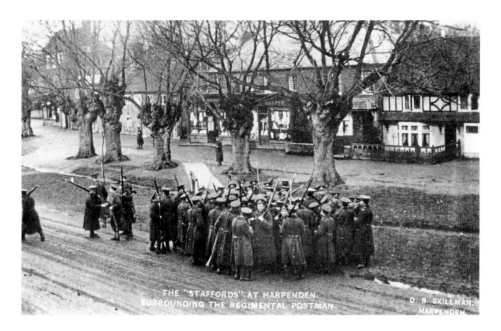

Collecting the Mail

An informal view of some of The 'Staffords' collecting their mail from the regimental postman in the High Street just opposite Church Green. The soldiers were from the North and South Staffordshire Regiments who arrived in Harpenden early in 1915. In February, the funeral took place of one of their number, a young soldier who had died of influenza at the Institute, the hospital in Southdown Road, after a few days of illness. He was just seventeen and had only enlisted in the Army a mere two and a half months earlier. He was buried in St Nicholas churchyard with full military honours while a bugler played 'The Last Post'.

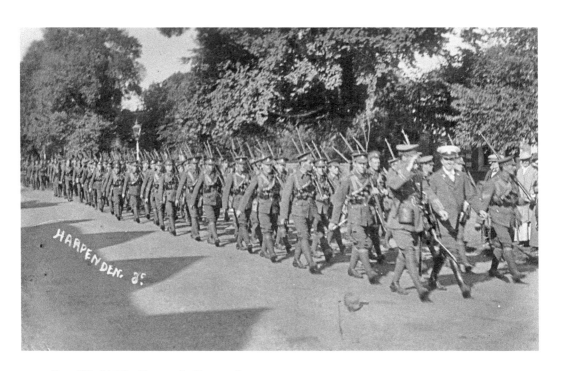

First World War Troops in Harpenden

Shortly after the outbreak of the First World War in August 1914, four battalions of the Notts and Derby Regiments (the Sherwood Foresters) were stationed in Harpenden for fitting-out and various training exercises, before their departure to Essex on 16 November, where they dug a defensive trench system in preparation for a rumoured German invasion. Their eventual embarkation to France took place on 25 February 1915. With over 4,000 men to house in the Village, the soldiers were billeted in private homes and other accommodation, while public buildings were requisitioned for administrative purposes and to serve as messes.

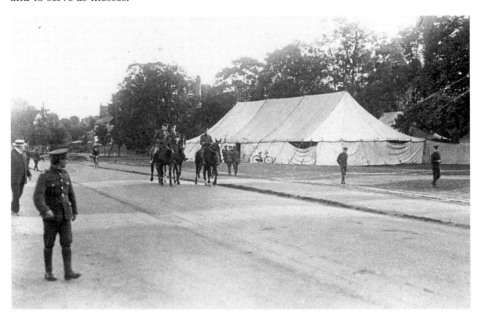

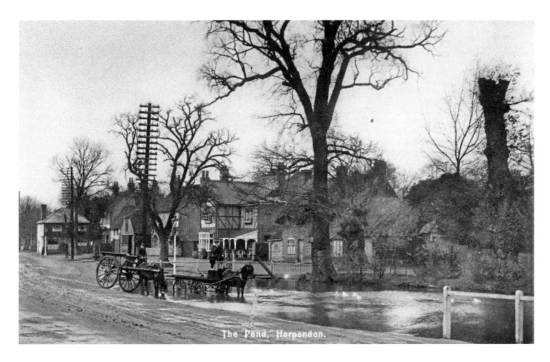

The Pond, Harpenden.

The Village Pond

This delightful rural scene shows a couple of carters watering their horses in the Village pond just opposite the Old Cock Inn. Although the pond was fed by a spring, its size fluctuated depending on the amount of rainfall there had been. A small stream ran from it along the edge of Lower High Street to the ponds on the Common, but with the steady increase in motor traffic the pond was filled in and the water from the stream piped underground during the late 1920s. The Forester's Arms public house, known as Cobweb Hall, can be seen in the background next to two picturesque thatched cottages, which were eventually demolished in the 1930s to make way for Reads' Motor Works new showrooms on the recently constructed Bowers Parade.

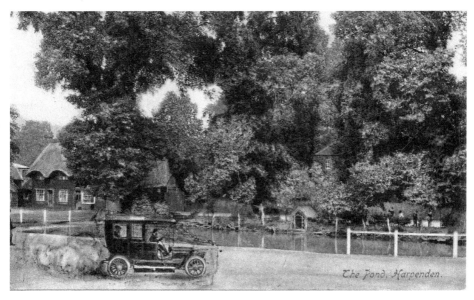

The Pond, Harpenden.

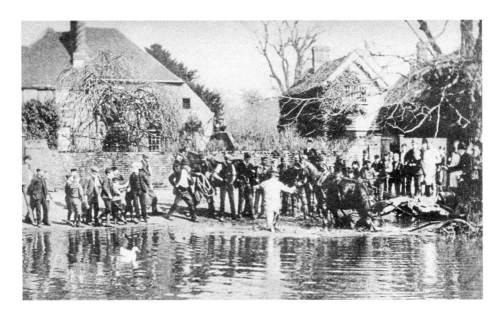

Incident at the Cock Pond!

A small crowd has gathered round the Cock Pond where William Hogg, a local cabbie, has driven his horse into the water to cool off, only for the poor animal to get stuck in the mud. Soon, helping hands were rallying round to get the horse back on *terra firma* again, presumably none the worse for its unfortunate experience. Mr Hogg was a well-known character in the Village for a great many years, plying his horse-driven cab for hire in Station Approach until his death in 1936 aged sixty-five. Just before the outbreak of the Second World War, an air-raid shelter was constructed on the site of the now filled in pond, one of four such shelters to be built in the locality. Today, the lovely Sensory Garden featured below occupies the landscaped area, with part of Harpenden's wartime preparations still existing just under the surface.

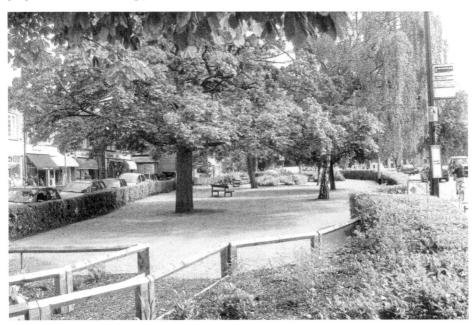

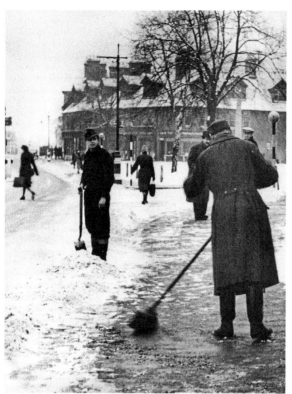

German Prisoners of War Clearing Snow I

With the island site shops in the background, these German prisoners of war are being fully utilised in clearing snow from the pavements in the High Street near Church Green. The prisoners of war were brought into the Village by lorry from their camp just south of Sauncy Wood in the direction of Mackerye End. It was originally set up to house Italian prisoners, but from 1944 until 1948 German captives were incarcerated there. The camp was opened in 1943 and held just under 1,000 people. As the war drew to a close, the prisoners were allowed out on a daily basis, either to work on the land or to be gainfully occupied, as seen on the left, in a variety of manual tasks for the council.

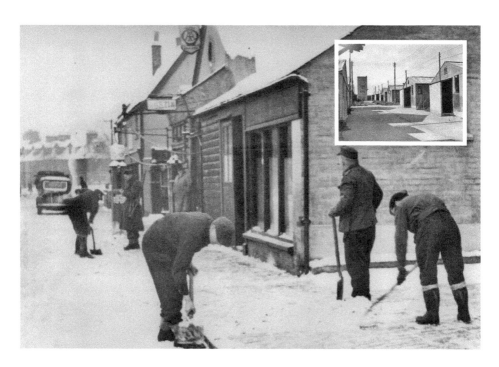

German Prisoners of War Clearing Snow II

Another group of German prisoners are industriously clearing snow under the watchful eye of an armed guard outside the photographic studio in the High Street, belonging to Frederick Thurston who, during the early part of the twentieth century, captured numerous images of Harpenden and the Common. The premises were demolished in the mid-1950s and the site was eventually incorporated into a Kwik Fit tyre and exhaust centre. Following the prisoners' repatriation after the war, their camp (*see inset*) was completely renovated and used to help meet the acute shortage of housing that existed at the time.

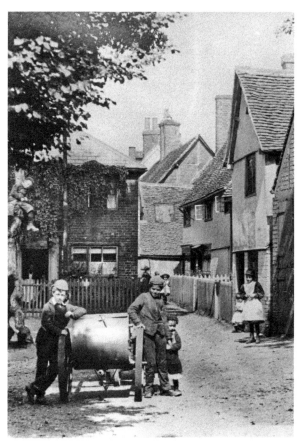

The Local Blacksmith

Before tarmacadam was introduced, a hand-operated water cart such as the one that the young lads are leaning on was used to lay the dust on the stone-surfaced roads. This cart was photographed outside the blacksmith's, H. Lines, situated near the Cock Pond. The forge, which was built in 1820, closed in 1957 after being worked by three generations of the Lines family. Older residents will remember Mr Lines shoeing a horse or pumping up the fire with his bellows, as well as recalling the smell of the horses and the red-hot metal as a shoe was fitted to a horse's hoof. Anvil House, a parade of shops with flats above, now occupies the site of the smithy, which was demolished in 1960 together with the houses on either side.

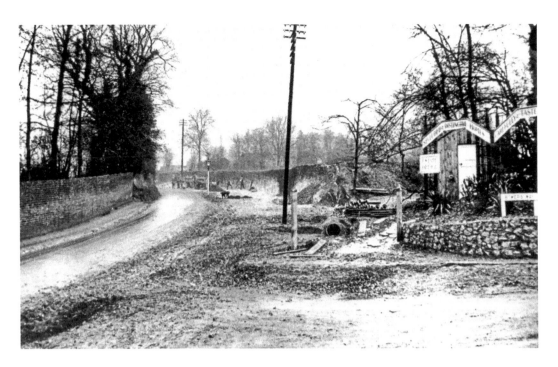

Bowers Way

Originally a cul-de-sac, Bowers Way, a turning on the right-hand side as you travelled up Sun Lane from the High Street, was built in the early 1930s at the same time that the lane was widened. The sign above the Estate Office offers 'Secluded & Distinctive Houses, Carefully & Tastefully Decorated', a claim that these were and still are highly desirable residences. Bowers Way was eventually linked with Victoria Road in the 1960s.

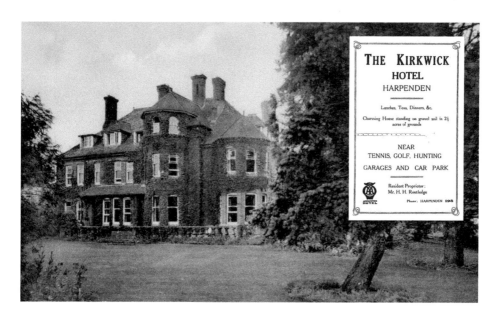

THE KIRKWICK
HOTEL
HARPENDEN

Lunches, Teas, Dinners, &c.

Charming House standing on gravel soil in 2½ acres of grounds

NEAR
TENNIS, GOLF, HUNTING

GARAGES AND CAR PARK

Resident Proprietor:
Mr. H. H. Routledge

Phone: HARPENDEN 198

The Kirkwick Hotel

At the north end of the Village, adjacent to Townsend Lane, was the large nineteenth-century house, built in the 1880s for Captain Charles Braithwaite, the first chairman and subsequently the president of Harpenden Conservative Club. By 1928, following Charles's move to Hove eight years earlier, the house had become The Kirkwick Hotel, where the proprietor in 1935 was Mr H. H. Routledge. Their advertisement at the time described the accommodation as a 'Charming House standing on gravel in 2½ acres of grounds', although what the significance is of mentioning the type of ground formation is not known. A further change of ownership took place in 1939 when it was renamed The Glen Eagle. Today, as the Glen Eagle Manor, the modernised fifty-two-room hotel is now closed pending redevelopment.

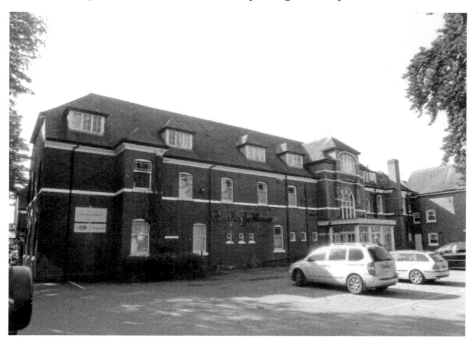

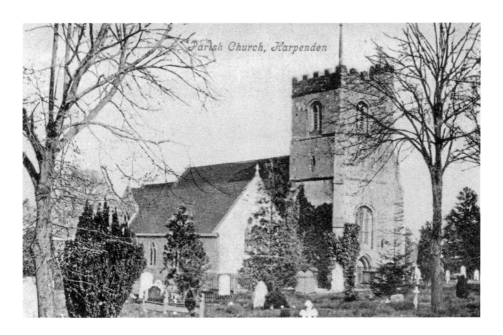

St Nicholas Parish Church

The lovely parish church of St Nicholas, seen above in a postcard sent on 14 April 1905, was originally built in the thirteenth century as a chapel of ease to the mother church of St Helen's in Wheathampstead, remaining as such until 1859 when St Nicholas became a parish in its own right. Although most of the old church was demolished in the early 1860s to be replaced by a larger building, the tower dates back to 1470. The new church was consecrated on 7 November 1862 with Canon Vaughan as Harpenden's first rector. In a quiet corner of the adjoining churchyard, the Portland stone or Italian limestone headstones of the fourteen military burials that took place here, mostly of those soldiers who had given the ultimate sacrifice in the First World War – 'the war to end all wars' – can be seen.

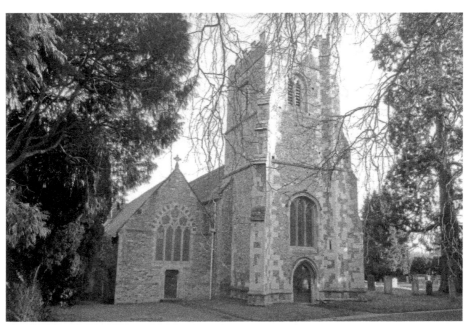

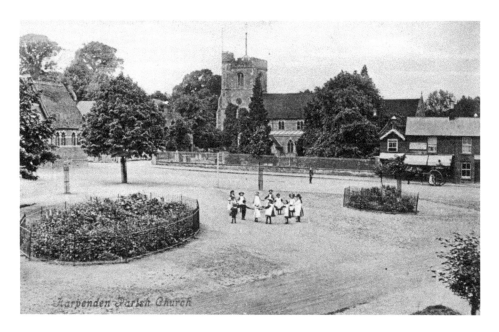

Church Green

Church Green as depicted on a card posted in 1904. The message reads, 'Is not this a pretty picture of the church and school? The children look as if they know they are being photographed. The Church Green has been much improved in late years. I will send you another (card) later on. Love to all. Yours C. S.' The Church School can just be seen on the left while the premises of Robert George Sampson, fish dealer, are situated at the end of the row of shops next to the small weather-boarded building, which was constructed in 1857 on the site of the Village 'lock-up'. Over a hundred years later and the same view still makes a pretty picture in this delightful part of the town.

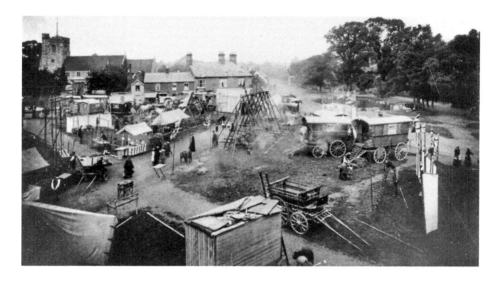

All the Fun of the Fair

During those halcyon days in Harpenden before the First World War, one of the highlights in the Village that was eagerly looked forward to, especially by the children and young people, was the arrival of the Statute Fair or the 'Statty' as it was more popularly known. This annual event with its roundabouts, swingboats and various stalls took place on Church Green on the third Tuesday of September. In bygone days, the origins of the Statute Fair, also called a hiring fair, meant local employers had the opportunity to choose and recruit additional labour, such as farmworkers, domestic servants or artisans. Once agreement had been reached, the employer would give his new worker a small sum of money to spend among the stalls set up at the fair. These days, though, the event is now held on the Common and is purely for pleasure only as can be seen below.

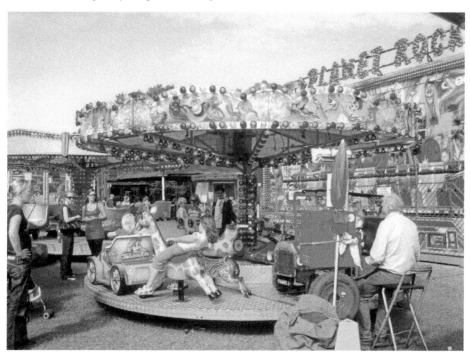

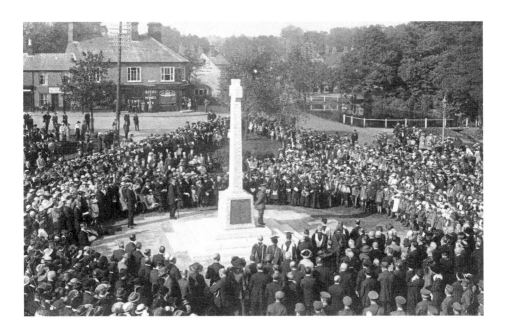

Unveiling the War Memorial

Saturday 9 October 1920 was a special day in Harpenden when the war memorial, dedicated to the local men who had fought and died in the First World War, was unveiled at a special ceremony on Church Green by Lieutenant-General Lord Cavan, who had travelled the short distance from his home, Wheathampstead House, in the nearby village of Wheathampstead. Many important dignitaries, as well as a large crowd of people, had gathered to witness the historic event. The names of the 164 men who had laid down their lives are inscribed on two gunmetal tablets on the granite Celtic wheel cross, with a further 110 names being added after the Second World War.

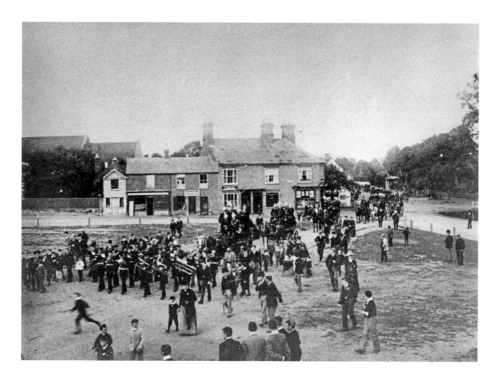

Fire!

A fascinating image from Harpenden's bygone past is depicted here in 1893, as throngs of people surge across Church Green while rival fire brigades, in accompaniment with a brass band, drive their horse-drawn appliances to Rothamsted Park to participate in various contests and sporting events. The photograph below, taken seventeen years later on August Bank Holiday Monday 1910, features the local fire service, who had organised a series of fundraising activities towards the purchase of a second-hand Shand & Mason steam-operated fire engine, popularly known as a 'steamer', which they were eventually able to obtain in 1912 for the princely sum of £185.

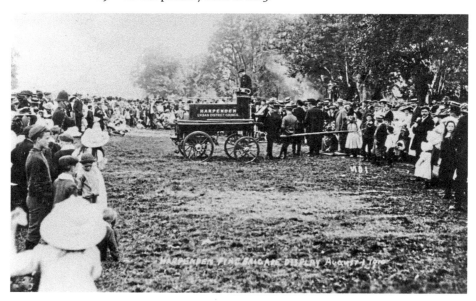

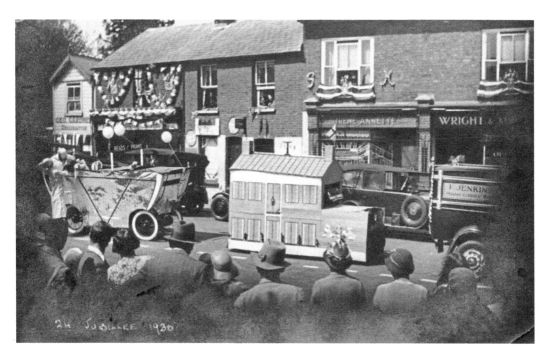

Silver Jubilee of King George V Some of the spectators gathered along part of the route to watch the decorated floats and tableaux of the procession passing through Church Green to celebrate the Silver Jubilee of their majesties King George V and Queen Mary in May 1935. In the background some of the various business premises can be seen, decked out in red, white and blue bunting for the occasion, including: George Gardner, decorator; Robert Sampson, fish dealer; Harold Bear, confectioner; 'Irene Annette', the hairdressing salon of Misses Bateman and Morgan; and just visible on the right, Wright & Mills, ophthalmic opticians. Nearly eighty years later, with different retail outlets trading, these same buildings make an attractive view on this side of the Green.

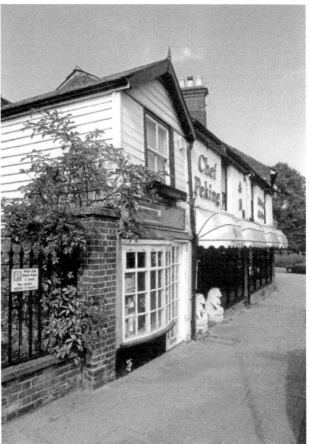

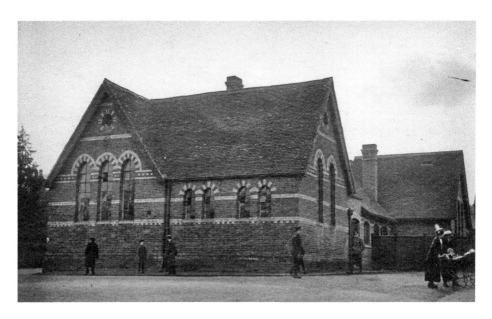

St Nicholas Church School

Pictured in the early days of the First World War, St Nicholas Church School, or the National School as it was known, was originally founded in the late 1850s in a thatched cottage on the site of the present structure, which was erected in 1864 and opened on 2 January the following year. This resulted in Mrs Whitehouse, wife of the local tobacconist and newsagent, losing the pupils she had taught from the small school that she ran from her home. To compensate for her misfortune, the Lydekkers, one of Harpenden's oldest families, kindly helped to set her up in a small shop selling various items of stationery. During its early years, the National School had an attendance of around 60 pupils, rising to over 100 by 1870. Now St Nicholas Church of England Voluntary Aided School, this lovely old locally listed Victorian building caters for children between the ages of four and eleven.

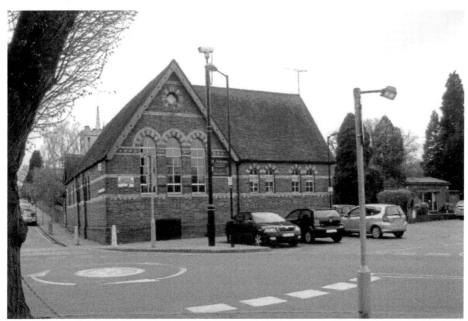

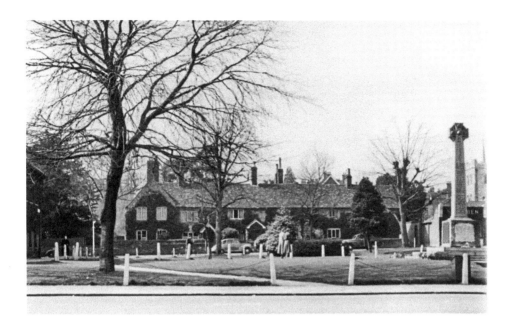

Batchelor's Row

Known as Batchelor's Row, these picturesque seventeenth-century cottages facing Church Green were occupied at one time or another during the 1920s and 1930s by: George William Curl, the parish clerk and sexton; Miss Morgan, the headmistress of the nearby Church Infant School; and the surgery of Doctors Fraser, Maclean and Ross, to name but a few. The butcher's shop of Walter Steabben is just visible behind the war memorial. The cottages survived until the late 1950s when they were demolished, despite much local opposition, to make way for a parade of shops and Harpenden's first supermarket, now occupied by Marks & Spencer Simply Food.

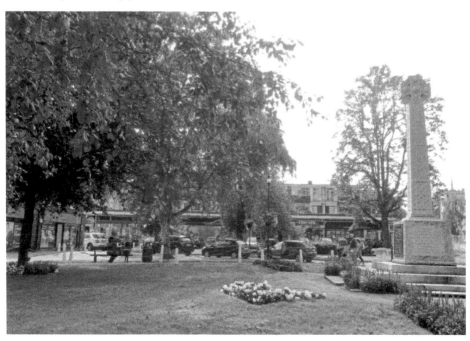

53

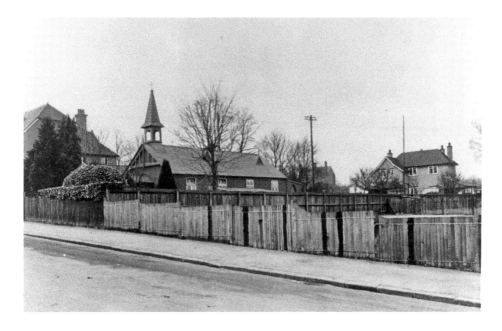

The Church of Our Lady of Lourdes

This 'temporary' corrugated-iron Roman Catholic church was opened on 28 May 1905 on a site in Rothamsted Avenue and served the community for over twenty-four years. Until a resident priest was appointed in 1919, the church was served by priests from St Albans to say Mass in Harpenden. The foundation stone of the present Church of Our Lady of Lourdes was laid on 4 August 1928 by Cardinal Bourne, with the opening at the end of October 1929 at a cost of nearly £20,000. The church was eventually consecrated on 28 May 1936, thirty-one years to the day that the original corrugated iron place of worship had opened its doors.

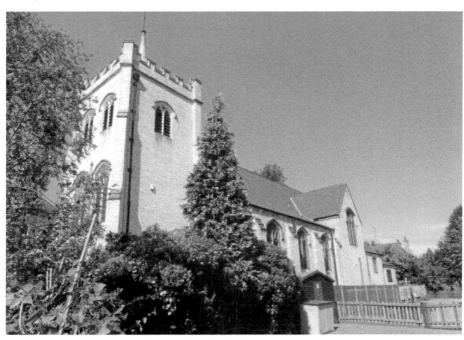

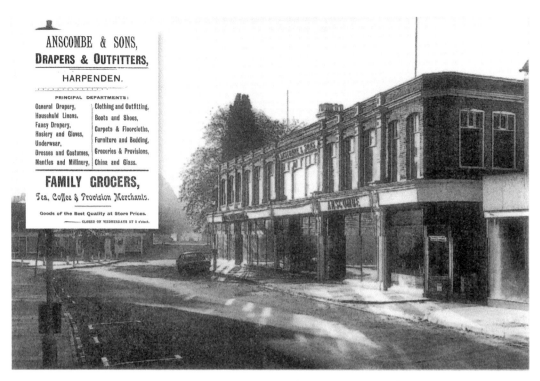

ANSCOMBE & SONS,
DRAPERS & OUTFITTERS,
HARPENDEN.

PRINCIPAL DEPARTMENTS:

General Drapery,	Clothing and Outfitting,
Household Linens,	Boots and Shoes,
Fancy Drapery,	Carpets & Floorcloths,
Hosiery and Gloves,	Furniture and Bedding,
Underwear,	Groceries & Provisions,
Dresses and Costumes,	
Mantles and Millinery,	China and Glass.

FAMILY GROCERS,
Tea, Coffee & Provision Merchants.

Goods of the Best Quality at Store Prices.
CLOSED ON WEDNESDAYS AT 2 o'clock.

Anscombe's

At one time Harpenden's most prestigious shop, Anscombe's in Leyton Road exuded its own special brand of old-world charm. It was founded in 1855 by Allen Anscombe, who started trading in a shop at the bottom of Thompson's Close. With the transfer of the business to Wellington House in 1874, the firm grew and over the years was extended along Leyton Road. The shop sold a variety of goods including haberdashery, linen, hosiery, menswear, and furniture. A fascinating feature of the store was the overhead cash rail system called 'Rapid Wire', where money was catapulted in a container with a detachable cup across the shop on a wire to the cash desk. There the cashier would receipt the bill and return the container, together with any change, to the counter from where it had come. Meanwhile, the assistant had time to wrap the goods and possibly pass the time of day with the customer. Anscombe's closed in 1982 and a Waitrose supermarket now occupies the site.

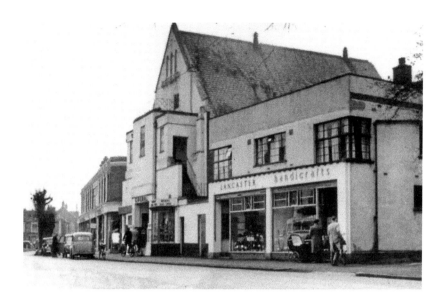

The Regent Cinema

With the new Methodist church in Lower High Street holding its first service in September 1930, the recently vacated chapel in Leyton Road remained empty for a few years until the building was acquired by Margaret Howard, who converted it into a 333-seater cinema complete with a balcony. Following a makeover with a new white frontage and multicoloured neon lighting, the Regent opened its doors with an all-British programme on 26 May 1933. The external metal staircase seen above led to the small projection room where most of the space was taken up by two enormous British Thomas Huston (BTH) projectors. The cinema was then leased to a Mr Southgate who eventually bought it in 1936. In the week ending 19 September 1959 the Regent, by this time renamed the State, closed with its final performance, a French film and an old Charlie Chaplin movie, *The Pilgrim*, released in 1923. The cinema was subsequently purchased by Anscombe's, who used the converted premises as a furniture showroom, until the site was eventually redeveloped as a Waitrose supermarket.

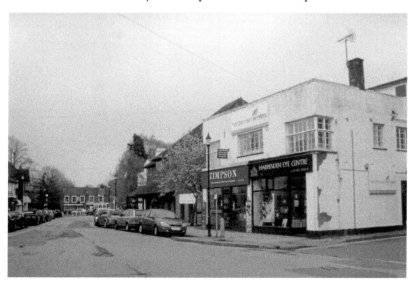

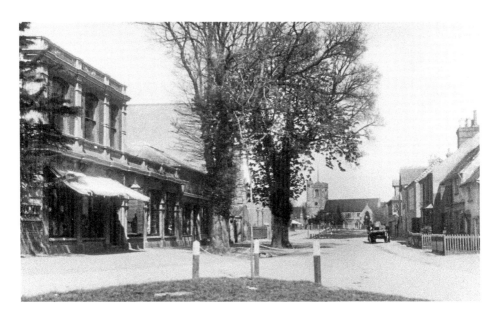

Leyton Road Looking North

Leyton Road in the 1890s looking north towards the parish church with Anscombe's on the left and the premises of William Gibbons & Son, bootmakers just visible on the right. During the 1930s, Anscombe's produced a brochure describing themselves as being 'In a quiet backwater away from the main stream of traffic, half hidden by fine old trees, is a dignified, well-proportioned two-storey run of shop front and showroom', which indeed it was. The 'fine old trees' were removed in 1962 and the store closed twenty years later.

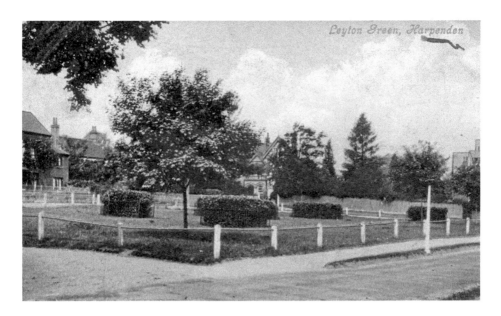

Leyton Green

Just south of Anscombe's is an attractive open space called Leyton Green, shown here on a card with the postmark dated 8 September 1908. On the left is Amenbury Lane, where the Salvation Army had their premises. It wasn't until 1966 that a new Citadel was built a short distance away on the site of a demolished house that had stood on the perimeter of the Green. In 1913, Harpenden's first cinema, the White Palace, occupied a position on the corner of Amenbury Lane at the junction with Leyton Road. The 450-seat theatre, subsequently renamed the Victoria Palace, was bought by Mr and Mrs Howard in 1931 who closed it two years later as being 'no longer adequate', with Margaret Howard opening the Regent cinema further along the road. In 1939, just prior to the start of the Second World War, an air-raid shelter was constructed on the Green, one of four that were erected in the Village at that time. Today, there appears to be very little outward change to this lovely, quiet backwater, apart from the ever-present motor car and the substantial growth of the tree in the foreground.

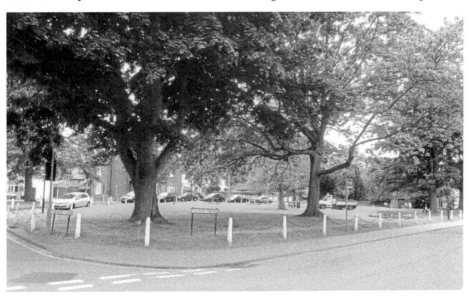

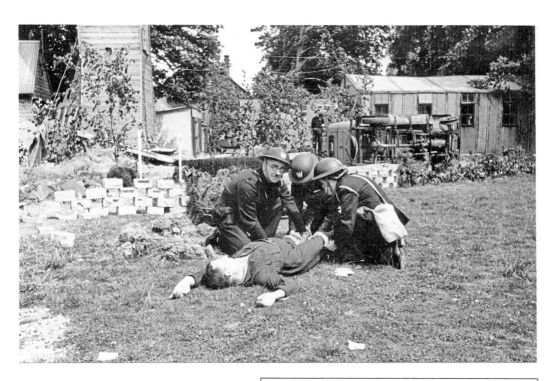

Civil Defence

During the Second World War, the area behind Park Hall in Leyton Road was very often used for Civil Defence exercises similar to the one depicted above in August 1942, where a 'bombing casualty' is being attended to by some of the wardens. Within the remit of the Civil Defence Service was Air Raid Precautions, an organisation set up to protect the populace from the danger of air raids. Among many other duties, they also ensured that the blackout was maintained. The local controller of the ARP in those days was Mr F. N. Gingell, the managing director of Harpenden Dairies in Station Road, who was also a member of the Urban District Council. The only house to be completely destroyed by a high explosive bomb during the war was No. 10 Crabtree Lane, which sustained a direct hit on the night of Sunday 20 October 1940. Fortunately, the occupants of the dwelling, a mother and her daughter, escaped injury, although both were badly shocked.

A few facts and figures for Harpenden

High Explosive Bombs	41
Oil Incendiary Bombs	1
Incendiary Bombs	2,099
Phosphorus Bombs	10
Crashed Aircraft (British)	1
Alerts	941
Houses Damaged	180

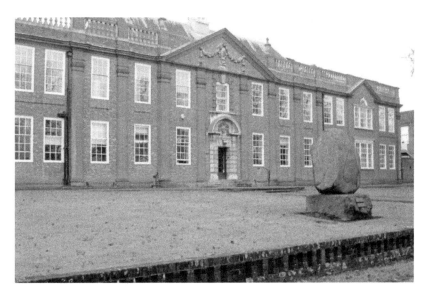

Rothamsted Experimental Station

Rothamsted Experimental Station was founded in 1843 by John Bennet Lawes, the owner of the Rothamsted estate, who as a young man had been interested in the effects of fertilisers on crop growth. It was in that year that he, together with Dr Joseph Gilbert, started a series of field experiments to develop and establish the principles of crop nutrition. The Russell Building above was a purpose-made laboratory, constructed in 1917, and replaced the old Testimonial Building, built in 1855 by public subscription of farmers nationwide, which was presented to John Lawes and Dr Gilbert in appreciation of the benefits their experiments were bringing to agriculture. The Shap granite monument on the front lawn was erected in 1893 to commemorate fifty years of research, being transported from Westmorland to Harpenden and thence by horse and cart to its present site. The tractor seen below in the Broadbalk field, where wheat has been sown and harvested every year since 1843, was acquired by Rothamsted towards the end of the First World War. Being what we would call 'a new-fangled contraption', however, it was not immediately popular with the older farmworkers.

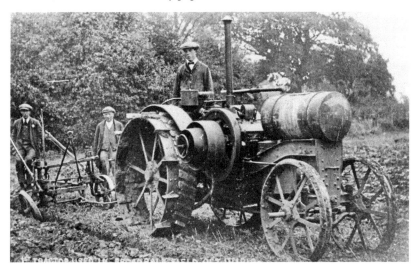

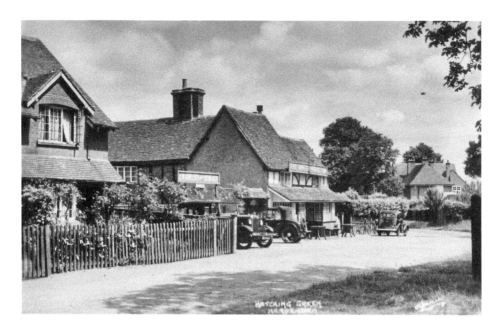

Hatching Green

This delightful 1930s image is of the seventeenth-century Grade II listed White Horse public house, situated on a quiet country lane on what is now the B487 to Redbourn, in the small hamlet of Hatching Green, a five-minute drive from the busy centre of Harpenden. Further round the Green to the left is Manor Drive, once the main access point to historic Rothamsted Manor, where John Bennet Lawes, the founder of the Experimental Station, was born on 28 December 1814. Today, the Manor House forms an integral part of Rothamsted Research, offering accommodation to visiting overseas scientists and students training on site.

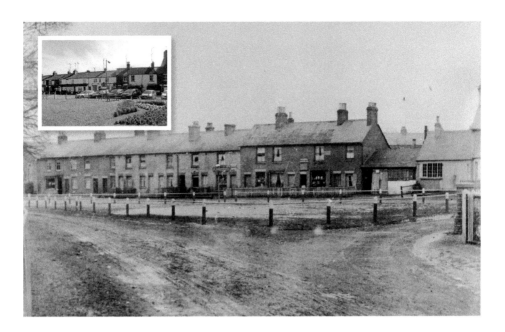

Southdown I

Southdown, or the Bowling Alley as it was known, is pictured above in the 1880s with the blacksmith's forge of Charles Ogglesby below. Following Charles's death in 1912, his son Frederick (standing next to the small boy) took over the business and before long was making and repairing bicycles to order. In the 1920s, the smithy moved to the other side of the Walkers Road railway bridge, near to the junction with St John's Road, with the original site of the forge eventually becoming a thriving motor garage. The vista of the old cottages (inset) still forms an attractive backdrop to the Green in this lovely suburb of Harpenden, although the garage and the St John's Road site have now been replaced with retirement homes and a block of flats.

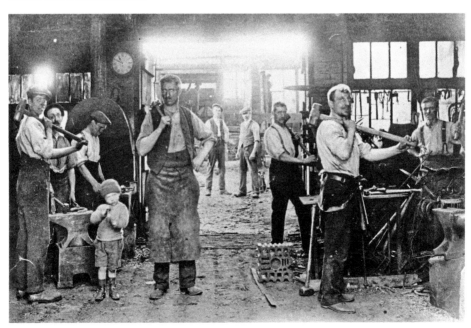

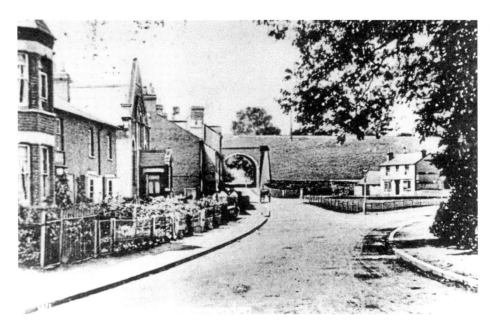

Southdown II

Another view of Southdown taken during the late 1860s, looking west towards the Walkers Road bridge, with the locally listed Rose and Crown public house on the right. The pub was built at the time when the area was expanding with the coming of the Midland Railway in 1868. The first landlord was Thomas Vine who was 'Mine Host' until his death in 1882, when his widow continued running the business until around 1890. Probably one of the longest serving licensees was William Hysom, who was landlord from 1908 until just before the outbreak of the Second World War. Following its eventual change to an Indian restaurant, the Rose and Crown Basmati, the premises are now closed and up for sale.

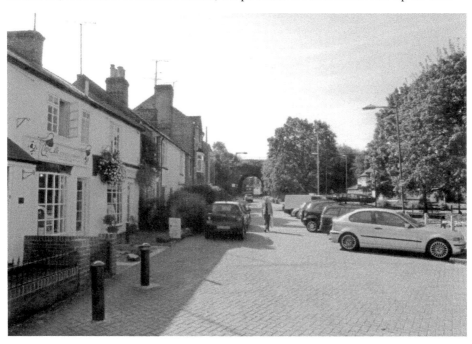

Phone **45**

T. ROLT & SONS

Removal and Haulage Contractors

DISTANCE NO OBJECT
ESTIMATES FREE

Sand and Gravel Merchants

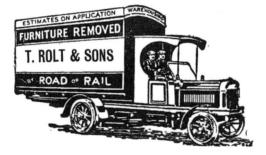

*Ansley Hard, Newdigate
Ryder Cobbles and Nuts.*

*Special Quotations for Truck
∴ ∴ Loads ∴ ∴*

Office:

54 SOUTHDOWN ROAD,
HARPENDEN

Piggottshill Lane

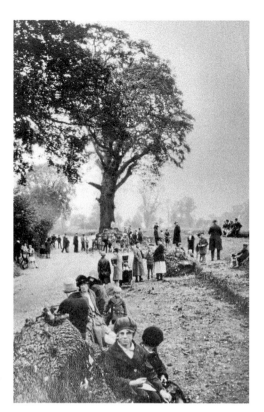

With the continuing growth of Southdown and in order to accommodate the steady increase in motorised traffic, a decision was made by the Urban District Council to fell a large tree in Piggottshill Lane so that the road could be widened. Tuesday 20 May 1930 was the day that workmen arrived to carry out the job, and with the local photographer in attendance and a small crowd of curious onlookers gathered to witness the event, the task was soon accomplished. The picture of Piggottshill Lane below was taken in September 2012 by the shops at the bottom of the hill.

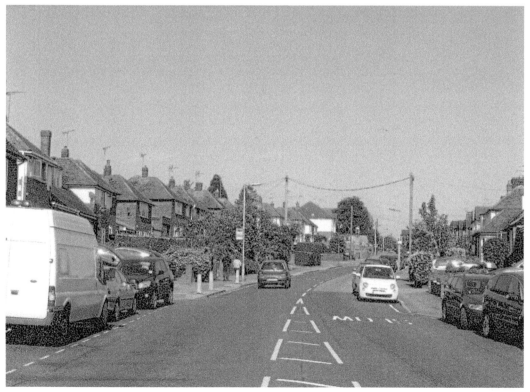

Skew Bridge

This wonderful old picture of Skew Bridge in Southdown Road was captured at just the right time by the photographer as the London train came into view on its approach to Harpenden. The bridge, truly an engineering feat, was constructed in 1865 in preparation for the Midland Railway line that was to pass through the Village, and which was opened in 1868. The old cottages on the right, which housed some of the bridge workers, were demolished in the 1960s when the site was redeveloped with modern housing. Today, the faded legend publicising *The Herts Advertiser* at Two Pence can still be seen above the arch of the bridge.

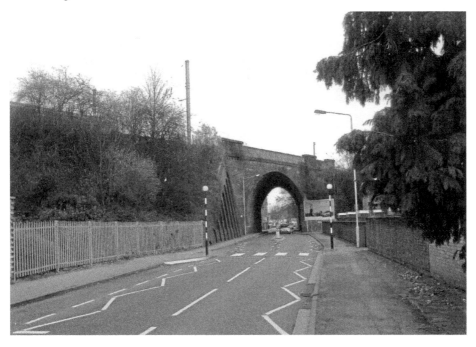

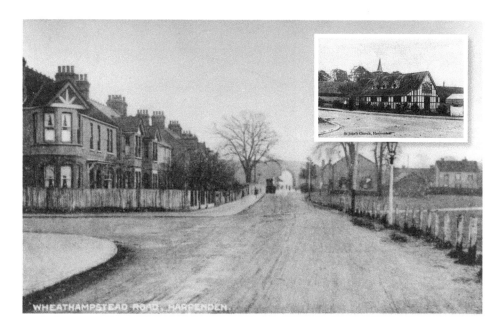

WHEATHAMPSTEAD ROAD, HARPENDEN.

Junction of Southdown Road and Crabtree Lane

Standing further back along Southdown Road, the Queen's Head public house can be seen to the left of the lamp-post in the image above. Before the corner of Crabtree Lane was developed for housing, the site was originally occupied by the timber-framed St John's church (*inset*), which was completely destroyed by fire on New Year's Eve 1905. It had only been erected for ten years. A new church was subsequently built a short distance away, with its consecration taking place on 2 March 1908. Today, the pub, now appropriately renamed Skew Bridge after the nearby railway arch, can just be seen through the trees on the right.

Junction of Station Road and Arden Grove

Eighty-five years have elapsed since that Thursday in August 1927 when this snapshot of Station Road at the junction with Arden Grove was taken. From a quiet, peaceful thoroughfare in those calm traffic-free days, it is now a busy link to Batford in the east of the town. Back in 1927, the advertisement on the wall proclaims that this is the home of Harpenden Dairies, a thriving business run by its managing director, Frederick Norman Gingell, a popular and ebullient man who was also chairman of the Urban District Council. It was Mr Gingell who introduced the scheme locally where each schoolchild was able to enjoy a daily 1/3 of a pint of milk to supplement the lack of nourishment that they were receiving between breakfast and lunch time, a scheme that was soon adopted nationally. Next to the dairy was where the new post office would shortly be constructed, which opened in September 1928. The property on the opposite corner belonged to Henry Salisbury, a local builder, who lived there until his death in 1923, when the premises became a dental practice run by Arthur Renwick Lambie and Harold Wardill until 1956. The house was demolished in the early 1960s when the site was redeveloped as a row of shops forming Harding Parade.

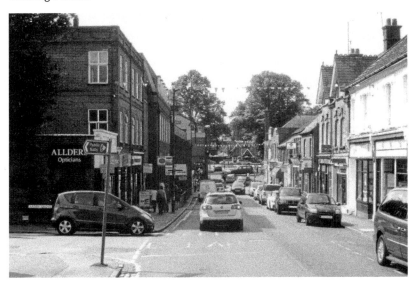

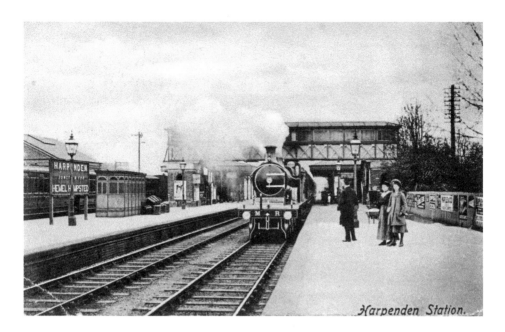

Harpenden Station.

Harpenden Station

In 1868, the Midland Railway main line extension from Bedford to London that passed through Harpenden opened its passenger service on 13 July, thus providing a direct and fast mode of travel to the capital. Initially there were two tracks, with a further two being added in 1905. With the railways came growth, and in 1882 building work commenced on land that had become available when the Packe and Pym estate of over 1,000 acres was sold. The first development to be built was the Park View estate, now the Milton Road area, followed by the Church Farm estate, which comprised the Avenues.

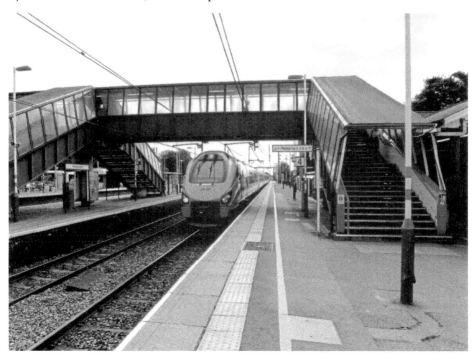

Victoria Road

The lone cyclist standing in Victoria Road in this somewhat grainy picture looks very much as though she is either posing for the photographer, or possibly just waiting for a friend. The large building on the right was completed in 1896 and opened as a school on 12 January 1897, with 140 boys and 120 girls, replacing the British School in Leyton Road, which had become too small. The new Congregational church, now the United Reformed church, is on the left, while the old police station (now a day nursery) can just be seen to the left of the school, the northern end of which until recently housed Harpenden Public Library before its relocation to new premises in the High Street. The Victoria Road building will eventually be occupied by the Harpenden Free School.

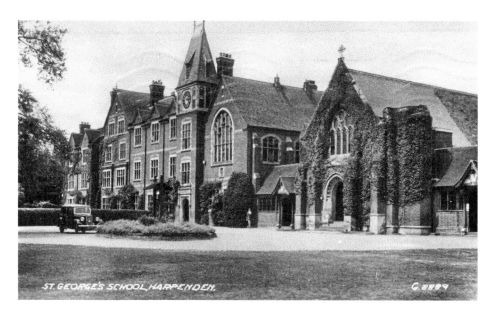

St George's School

In 1885, the purpose-built school that would be St George's was started, with possession taken at the end of January 1887 under the headmastership of Robert Henry Wix, a scholar of Peterhouse, Cambridge, who had been head of a school also called St George's in Brampton, Huntingdon. Following Mr Wix's retirement in 1904, the school buildings were leased to the United Services College who were only in residence until 1906. The following year, the present school was founded by the Revd Cecil Grant who, with his wife Lucy, had until recently been running a co-educational school in Keswick, based on firm Christian family principles. In 2007, St George's celebrated the centenary of its foundation, with the school anthem, 'Assurgit Skidda Stabilis', no doubt resounding with pride around the lovely chapel that had been built in 1891.

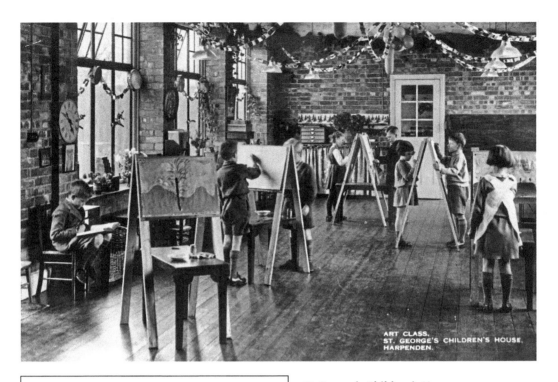

ART CLASS.
ST. GEORGE'S CHILDREN'S HOUSE,
HARPENDEN.

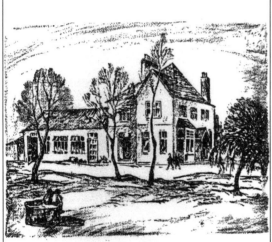

THE CHILDREN'S HOUSE
ST. GEORGE'S SCHOOL
HARPENDEN, STANDS ON
HIGH GROUND IN ITS OWN
GARDEN. IT IS A HOME
SCHOOL FOR CHILDREN
FROM TWO TO EIGHT YEARS

St George's Children's House

This charming Real Photo card posted on 11 May 1935 features the art class of St George's Children's House shortly before the Christmas break. An information leaflet of the time states, 'The Children's House, a Nursery School fitted and equipped for Boarders and Day Boarders between the ages of 2 and 8 years, stands in its own grounds adjoining St George's School. It is usual, though not necessary, for boys and girls to pass from the Children's House into the Second Form of the Lower School at St George's.' Children were taught under the Montessori educational approach developed by the Italian physician and educator, Maria Montessori, where emphasis was placed on free activity, the fostering of a team spirit, co-operation, consideration for others and respect for a child's natural psychological development. In December 1955, the Children's House ceased to be part of St George's when it moved to 'Gorselands' in Walkers Road, where it remained until its subsequent closure and redevelopment into private housing.

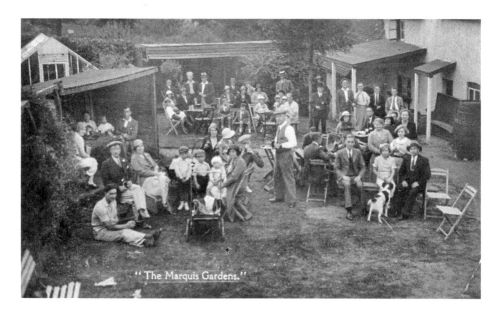

"The Marquis Gardens."

The Marquis of Granby Riverside Inn

Situated at the bottom of Crabtree Lane adjacent to the River Lea is the quaint eighteenth-century inn, the Grade II listed Marquis of Granby, offering a convivial atmosphere and traditional pub games such as crib, dominoes and darts. At one time the old pub had uninterrupted views across the nearby river and ford, where horses and wagons used to cross with their heavy loads, but with the passage of time, nature has reclaimed the riverbank, obstructing the vista with tall trees and vegetation. During the 1930s the landlord was Alfred Edward Mundy, Alf to his many regulars, some of whom are shown above enjoying relaxing drinks in the adjoining beer garden. In those days, in addition to being fully licensed, Alf provided teas and ices as well, a welcome touch on a warm summer's day by the water's edge.

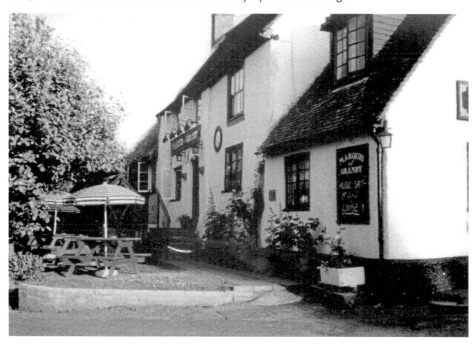

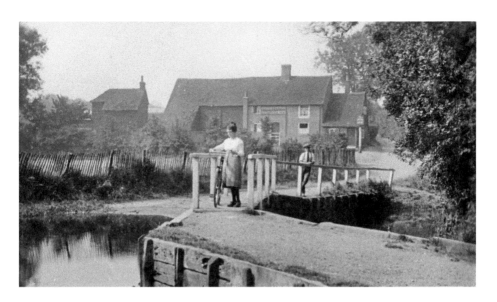

The Ford and the Marquis of Granby

An early view of the ford across the River Lea taken from the footbridge, with the Marquis of Granby clearly visible in the background before the outlook was eventually obscured by high trees and shrubs. Crabtree Lane can be seen next to the pub snaking its way into the distance towards Harpenden Common. A key event that takes place each year along the river is the annual Duck Race organised by the pub, where crowds of enthusiastic supporters gather on New Year's Day morning to watch and take part in the sponsored contest, with the money raised being donated to several worthwhile charities. Hundreds of plastic yellow ducks are launched at Batford Springs, with the first ones to reach the footbridge next to the old inn declared the winners who, no doubt in accompaniment with many of the spectators present, are eagerly looking forward to a welcome and well deserved pint.

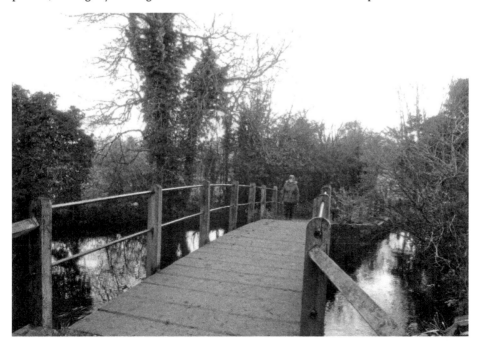

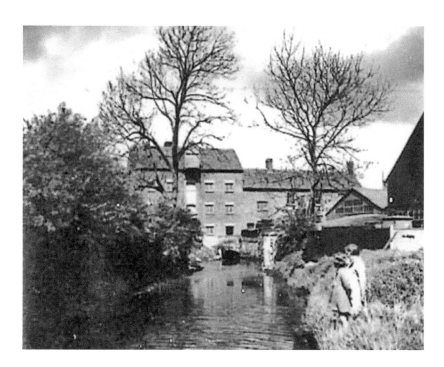

Batford Mill

Batford Mill, depicted in a photograph taken by the author's father, George Cooper, in the late 1930s. The mill was one of four in the parish of Wheathampstead, which included Harpenden, mentioned in the Domesday Book of 1086. Today the old mill has been completely renovated and is occupied by offices and industrial units. There is little evidence now to show where the River Lea once flowed, as it was diverted from its original course through the mill in 1954. Of the two little girls standing on the millstream bank, the one furthest from the photographer is the author's elder sister Pat, to whom this book is dedicated.

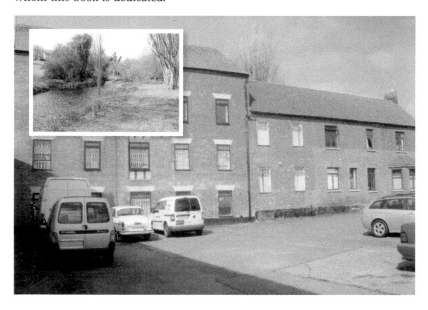

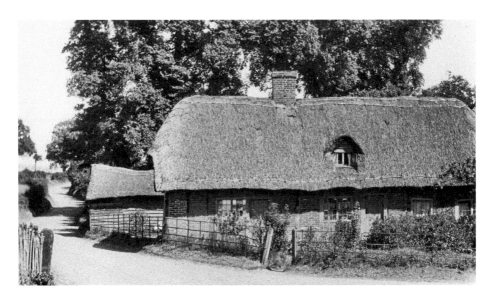

The Thatched Cottage

A short distance from the Marquis of Granby, across the River Lea near Batford Mill, are the lovely old seventeenth-century thatched cottages, as featured in the above photograph taken around 1925. Originally there were three dwellings but these were amalgamated into one in 1958. Earlier occupants of the cottages included an agricultural worker and William 'Shep' Arnold, a local shepherd who lived there with his large family. Each day he herded his flock from Mackerye End Farm to the Common by way of Crabtree Lane. Life in the cottages at the turn of the nineteenth century was very hard and basic. There was no indoor sanitation and water for washing had to be drawn from the nearby river. A spring close by provided the drinking water. The pristine Grade II listed cottage is pictured below in more modern-day times.

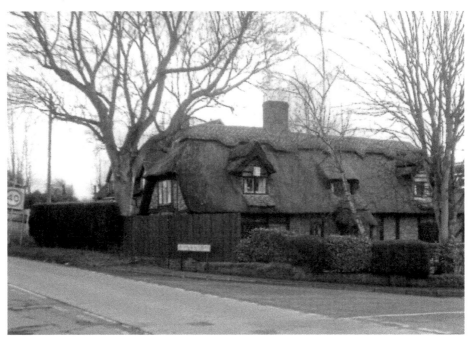

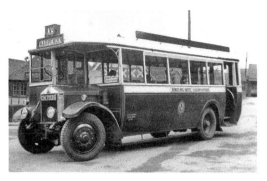
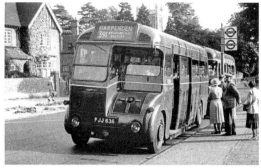

Public Transport

The lovely old bus featured on the left above was a thirty-two-seater Albion PM28, with a body by London, Midland & Scottish Railways (LM&S), probably built at Wolverton, and licensed on 1 August 1929. It was acquired by London General Country Services on 12 April 1933 for service on Route 307 between Boxmoor and Harpenden via Hemel Hempstead and Redbourn. The bus was withdrawn on 14 April 1936. Sixteen years later, on 28 June 1952, the No. 391 bus service (*above right*) is preparing to depart from St Albans for its journey through Wheathampstead and Batford to its destination at Church Green, Harpenden. This TF class of London Transport single-decker bus was introduced just prior to the Second World War, during which they were utilised on ambulance work, and would have had longer service lives had the RF class bus not replaced them in the 1950s. Note the radiator built into the distinctive curved nearside front wing. Below is a London Transport single-decker that used to travel between Harpenden and Batford in the early 1960s. Bus RW2, an AEC Reliance with a Willowbrook body, was one of three similar buses bought by London Transport, two of which have subsequently been preserved, when they were looking for a replacement for the RF class.

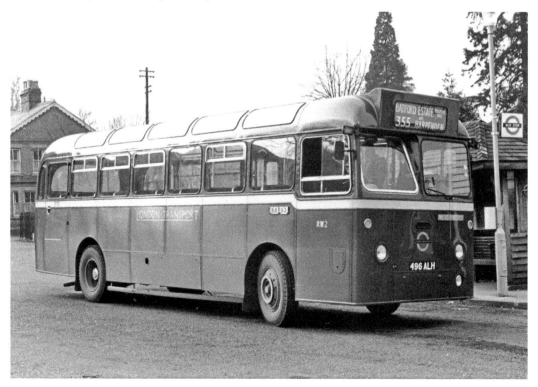

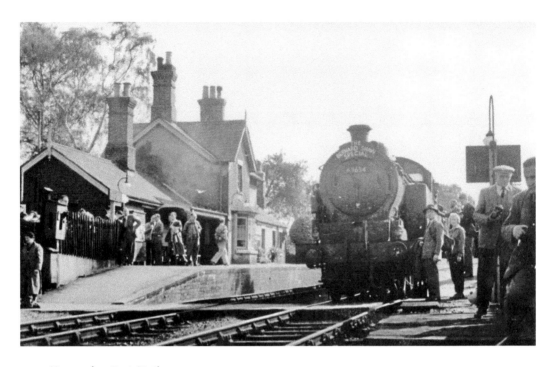

Harpenden East Station

Throngs of excited people line the platform as 'The Bernard Shaw Special' pulls into Harpenden East station on the Great Northern Railway branch line. The train pulled by engine No. 69654 was one of a series of day excursions that ran from either the Elephant and Castle station or Clapham Junction in London to Harpenden via Wheathampstead, where passengers would alight to make the short journey to visit George Bernard Shaw's house at Ayot St Lawrence. The railway opened on 1 September 1860, eight years before the Midland Railway, thus giving Harpenden its first rail link to London. With the line's closure to passenger traffic on 24 April 1965 and the subsequent demolition of the station and removal of the track, the area is now occupied by Waveney Road, a housing development.

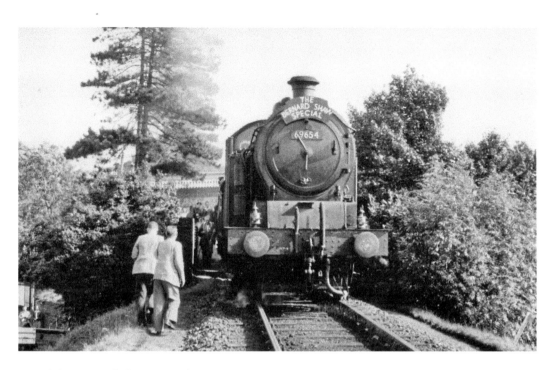

'The Bernard Shaw Special'

'The Bernard Shaw Special', pulled by engine No. 69654, is seen here in the 1950s at Wheathampstead station before travelling the short distance to Harpenden East. It was at Wheathampstead where the many devotees of the renowned Irish playwright George Bernard Shaw alighted to head for Shaw's Corner, now part of the National Trust, at nearby Ayot St Lawrence, the home of the great man, who lived there until his death on 2 November 1950, aged ninety-four. Below, this delightful Real Photo image of the station taken in the early 1900s depicts passengers awaiting the approaching train from Hatfield.

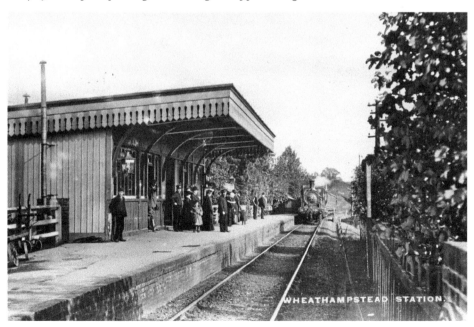

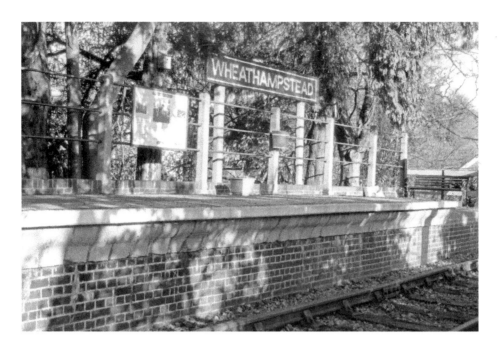

Wheathampstead Station

At first glance, this picture of Wheathampstead station taken on a bright November morning in 2012 appears to be just another stop on a quiet country branch line. However, on closer scrutiny of the photograph below, the posed 'commuters' waiting for a non-existent train that will never arrive are in fact a band of enthusiastic volunteers helping to preserve the delightful remains of the old station that closed nearly fifty years ago. Today, just one small section of railway track, which was opened in 1860, and where passenger trains once travelled between Dunstable and Hatfield, remains. It now forms part of the informative Wheathampstead Heritage Trail.

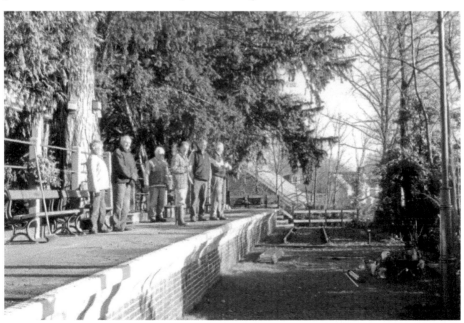

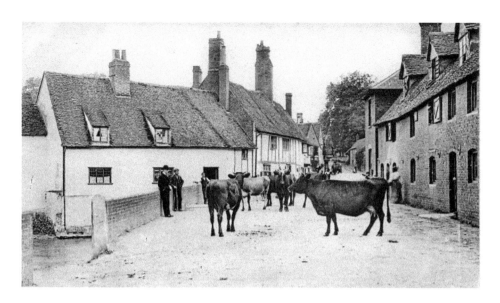

Mill Bridge, Wheathampstead

Over one hundred years separates these two images of the Mill Bridge, and yet remove the cattle and the car and time has literally stood still. This charming scene depicts on the left the Grade II listed Bull Inn, now the prestigious Miller & Carter Steakhouse and the old Mill on the right, one of four in the parish of Wheathampstead mentioned in the Domesday Book of 1086. The Bull, which was extended to take in two adjoining riverside cottages, is long and curving and has been plastered over and colour-washed. The original timber frame dates from the sixteenth century. It is believed that one of its most famous guests was Izaak Walton, the seventeenth-century writer who is best known as the author of *The Compleat Angler*.

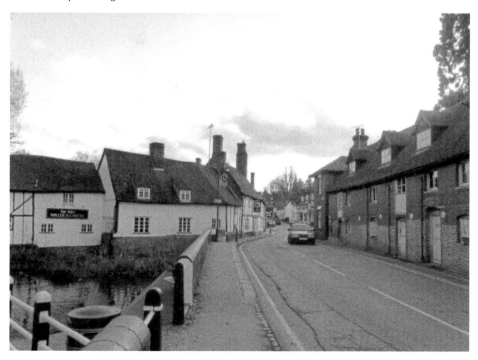

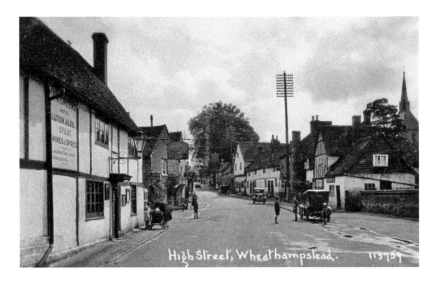

Wheathampstead High Street I

This attractive panorama of Wheathampstead High Street taken in the 1920s shows the Bull Inn on the left and the Grade II listed Two Brewers on the right, just behind the motor car. This seventeenth-century building, once one of the many pubs that the village boasted, had a popular innkeeper, James Westwood, who was not only the landlord, but was also a blacksmith, local fireman and a bell-ringer at St Helen's. It is said that on his death in 1910, the front window of the building had to be removed in order that the coffin could be carried out for his funeral. A short distance from the High Street is Wheathampstead's Crinkle Crankle walls; a unique Victorian brick feature situated west and east of the Old Rectory boundary. The wavy curvature of the wall's construction was such that it provided added strength without the need for supporting piers. The term 'crinkle crankle' is defined as something with bends and turns, although it is thought to come from the Old English meaning 'zigzag'.

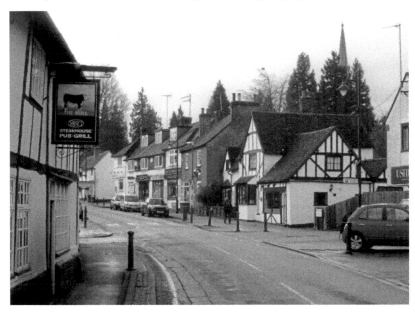

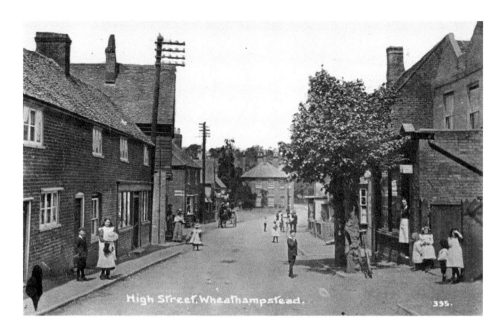

Wheathampstead High Street II

A delightful view of the High Street is seen here taken at the turn of the nineteenth century, where the arrival of the photographer appears to have created much interest, and in 2012, with part of the historic mill in the centre of both pictures, today trading as the Manor Pharmacy. Although many of the old buildings standing 100 years ago have since been demolished, lovely structures such as the Grade II listed White Cottage and Jessamine Cottage remain. From the 1880s, the Wren family, coachbuilders and wheelwrights, lived at the latter dwelling, next door to their place of work where the Jessamine Motor Company Ltd is now situated.

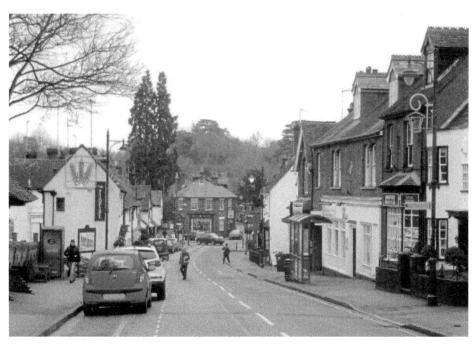

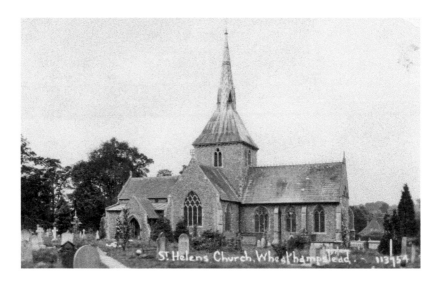

St Helen's Church

In 1060, King Edward the Confessor gave the whole area covering Wheathampstead and Harpenden to the Abbey of Westminster with St Helen's at Wheathampstead being the parish church. Although the church originates from Saxon/Norman times, there is very little to see now from that period apart from traces of a round-headed door in the south transept wall. Restoration work took place in the early thirteenth and fourteenth centuries, and extensive rebuilding was carried out in the 1860s, when the fine looking spire and slate roof were added. One of the more notable burials at St Helen's was that of Apsley Cherry-Garrard, an English explorer of Antarctica who, at the age of twenty-four, was the youngest member of the ill-fated Terra Nova expedition (1910–13) when Robert Falcon Scott, together with his four companions, perished on their return journey from the South Pole in early 1912. Later, Apsley Cherry-Gerrard returned to Lamer, the family home in Wheathampstead, and died in 1959 aged seventy-three. A statue within the church, now Grade I listed, is dedicated to the memory of the polar explorer.

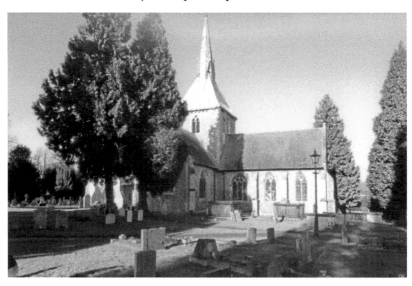

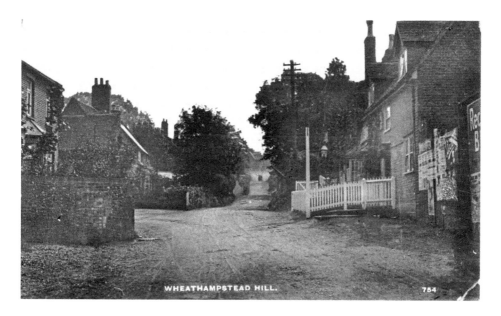

WHEATHAMPSTEAD HILL. 754

The Hill, Wheathampstead

Posted on 4 August 1920, this Real Photo card shows the junction of The Hill, straight ahead, with Marford Road on the left and the Grade II listed public house The Swan on the right. This charming early sixteenth-century village pub had, at one stage, not only its own brewery and malthouse, but accommodation for travellers as well. About 1/4 mile along Marford Road is Devil's Dyke, the name given to the remains of a massive defensive earthwork constructed around 2,000 years ago and surrounding an ancient settlement of the Catuvellauni tribe. It is believed that this was where Julius Caesar defeated the chieftain Cassivellaunus in 54 BC. Two sections of the ditch remain today: the western section, which is around 30 metres wide and 12 metres deep, and a smaller ditch to the east called The Slad. The whole site is now a Scheduled Ancient Monument.

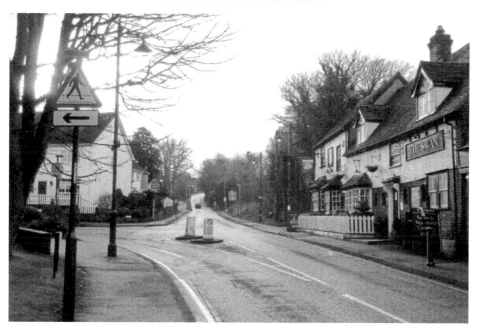

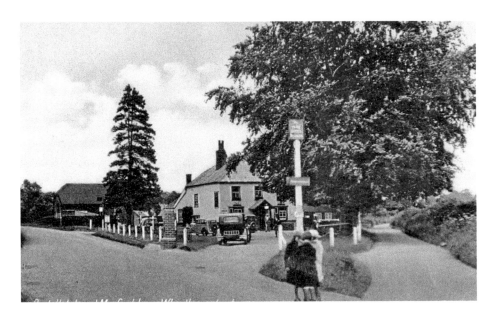

The Wicked Lady, Nomansland Common

A short distance from Wheathampstead and situated on the edge of historic Nomansland Common, where part of the Second Battle of St Albans occurred in 1460, is the Wicked Lady, a superb 'country pub and eating house'. Once called the Park Hotel and prior to that the King William IV, the Wicked Lady derived its name from the infamous Lady Katherine Ferrers of Markyate, presumed to be a notorious highwaywoman in the mid-seventeenth century. Although only twenty-six at the time of her death in 1660 from gunshot wounds sustained during a robbery, she had already built up a catalogue of mayhem in her short life. Legend has it that she now haunts the Ferrers family home, Markyate Cell, as well as Nomansland Common, where a dog walker recounted that he once heard the sound of a horse galloping towards him one dark night, passing so close that he could have reached out and touched it – but there was nothing to be seen!

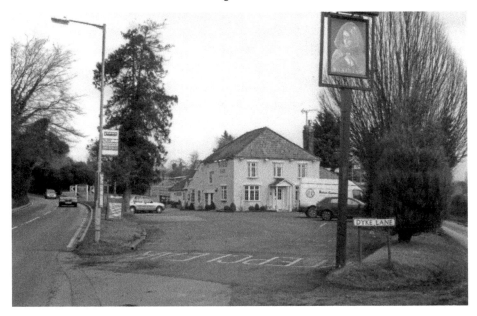

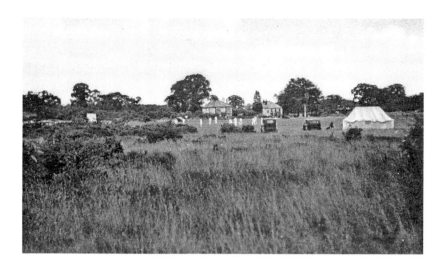

Wheathampstead Cricket Club

A quintessentially English village scene on a warm summer's afternoon in the 1930s is depicted here, where Wheathampstead, one of Hertfordshire's oldest established cricket clubs (1824), are enjoying a match on Nomansland Common. This was when the club did not possess the splendid pavilion that they have now, retiring after the game to the nearby Park Hotel, where, in an upstairs room, tea and post-match imbibing would be enjoyed by all. In the old days, when the roller was pulled by a horse, the horse's hooves had to be covered with sacking so as not to mark the pitch. It is believed that the first pavilion, a corrugated iron affair, was constructed shortly after the Second World War, around 1947. The new pavilion was built in 1965 and extended twenty years later. An interesting feature on the outfield of the cricket pitch is a 'Puddingstone', which, in the Middle Ages, formed the division between Wheathampstead and Sandridge, and marked the boundary between the rival monasteries of Westminster and St Albans. Today, with only a small part still visible, St Albans District Council have made provision for the preservation of the stone as an object of antiquity. The Park Hotel (now the Wicked Lady eating house) can be seen in the distance on the right.

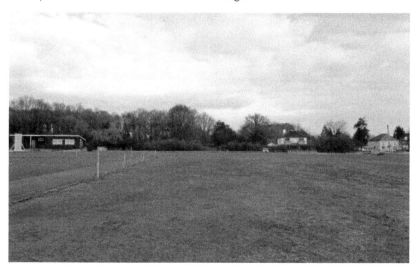

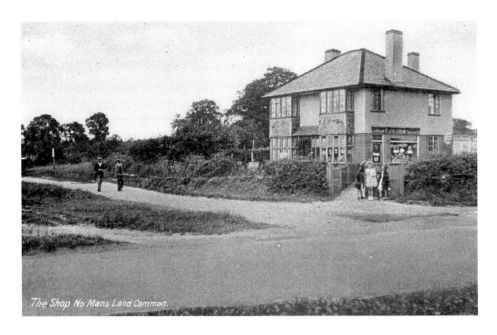

The Shop No Mans Land Common.

Silverlands, Nomansland Common

Silverlands, the white building on the left opposite the cricket pitch in the two previous images, was once a general store constructed in 1931 by Charles William Cook, the then landlord of the nearby Park Hotel, for his two daughters Caroline Rebecca and Grace to run. Following the shop's closure in 1950, the premises were then occupied, first by a Mrs Harding from 1950 until 1953, and then by Herbert Arthur Steerwood who ran a small holding there until 1966 when the property was bought by the current owners, initially as a boarding kennels and for breeding Scottish Terriers and West Highland White Terriers, but now as a private residence.

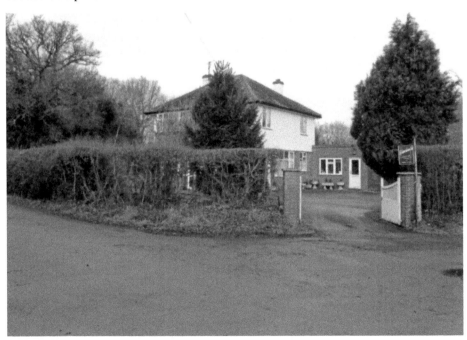

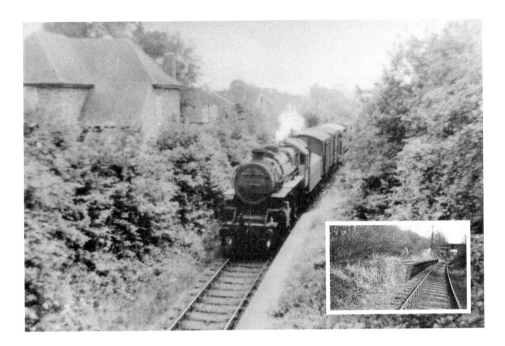

Roundwood Halt, Harpenden

A steam train is seen approaching Roundwood Halt in the early 1960s on the popularly named 'Nickey' branch line that ran between Hemel Hempstead and Harpenden. The line opened its first passenger service on Monday 16 July 1877 and continued until its closure in 1947, although freight traffic continued over part of the route for several more years. The line finally closed in 1979. Although the inset picture is of Godwins Halt, further back towards Hemel Hempstead, the image serves to illustrate how the undergrowth and flora are gradually encroaching on the area alongside the track. The photograph below shows part of an old concrete platform, a historic relic of all that remains of Roundwood Halt today.

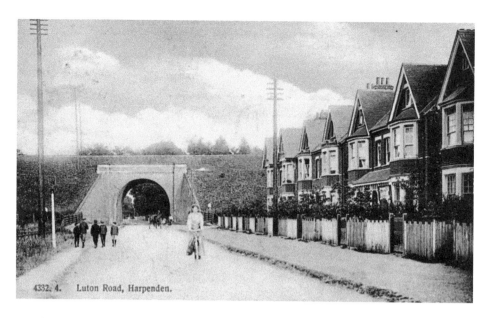

4332. 4. Luton Road, Harpenden.

North Harpenden

A quiet part of north Harpenden in the early 1900s is featured in this picture postcard, with the prominent feature of the Luton Road bridge, known locally as The Arch, in the background. The bridge was constructed in 1875 to carry the branch railway line between Harpenden and Hemel Hempstead, running a passenger service for over seventy years until its closure in 1947. During the dark days of the Second World War, in November 1942, the area became a hive of activity over one weekend as a combined exercise involving the local Home Guard and Civil Defence services was carried out. Watched by a team of military observers, a sustained attack was made on the bridge by the Home Guard, while low-flying aircraft from the United States Air Force added a touch of realism to the proceedings. With the railway tracks long gone, in their place is a leafy path with mature trees on either side, leading in one direction towards Harpenden and in the other towards Hemel Hempstead.

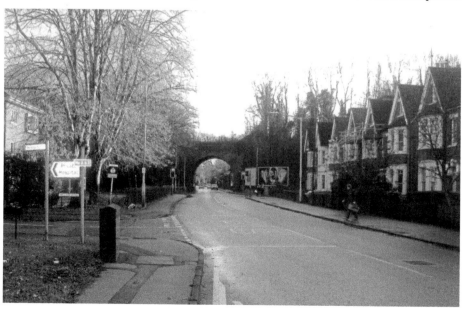

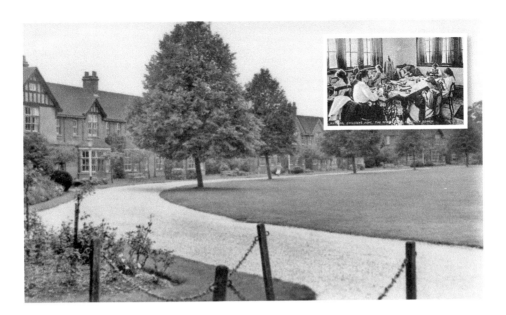

The National Children's Home

The National Children's Home was founded by Dr Thomas Bowman Stephenson in 1869, initially in a small cottage near Waterloo station in London, before moving to larger accommodation in Bonner Road, Bethnal Green, two years later. In 1913, the home transferred to a 300-acre site in Ambrose Lane, Harpenden, where a large central grass oval separated the girls' houses to the left of the entrance and the boys' to the right. Upon reaching school-leaving age, a variety of trades were taught and apprenticeships offered to the boys in the on-site Printing School. Girls were trained in various secretarial duties, such as shorthand and typewriting, or as seamstresses as depicted in the sewing class (*inset*). The whole area, comprising the grounds and buildings, was purchased by Youth With A Mission (YWAM), an international movement of Christians, in 1993.

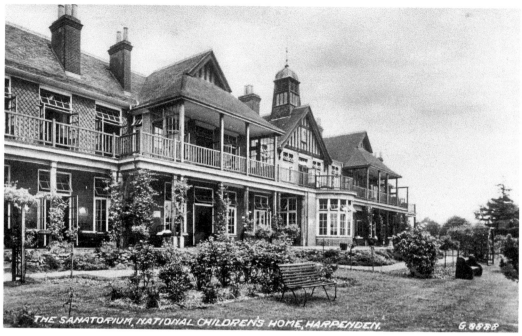

THE SANATORIUM, NATIONAL CHILDREN'S HOME, HARPENDEN. G.8888

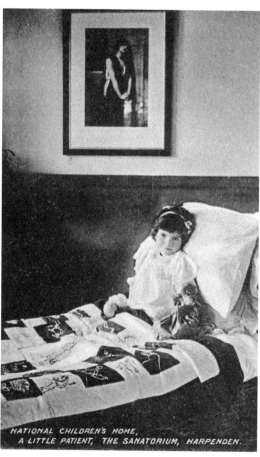

NATIONAL CHILDREN'S HOME,
A LITTLE PATIENT, THE SANATORIUM, HARPENDEN.

The Sanatorium, National Children's Home

This delightful building with its distinctive veranda overlooking the beautiful gardens was purpose-built in 1910 as a sanatorium, part of the National Children's Home, for children at risk of, or suffering from, tuberculosis. Situated in the rambling countryside on the outskirts of north Harpenden, a short distance from the orphanage, the young patients, such as the little girl on the left, were often wheeled onto the veranda during the summer months as it was felt that the benefits of fresh air were deemed to aid recovery. In 1987, The King's School, an independent Christian school, took over the lovely site.

Peace at Last!

Tuesday 8 May 1945 (VE Day) was the day when the war in Europe was won, although it would be another three months before the victory over Japan (VJ Day) was celebrated on 15 August, thus finally ending nearly six years of conflict that was the Second World War. With celebrations and victory bonfires being lit all over the country, Bloomfield Road was no exception, as can be seen on the right outside No. 37, with some of the residents and children (the author is the third from the right in the front row). All day, garden refuse and anything else that would burn had been dragged into the road, with the final touch, a suitably attired guy that had been quickly put together. The momentous day ended with a superb blaze as the neighbours drank beer and sang songs to the accompaniment of an old wind-up gramophone that someone had produced. The celebrations were over and the peace with its accompanying austerity was about to start.

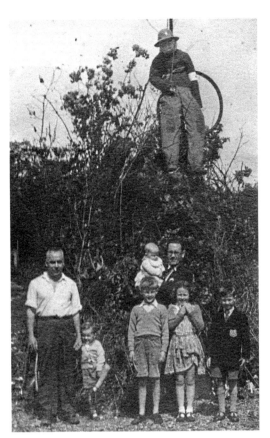

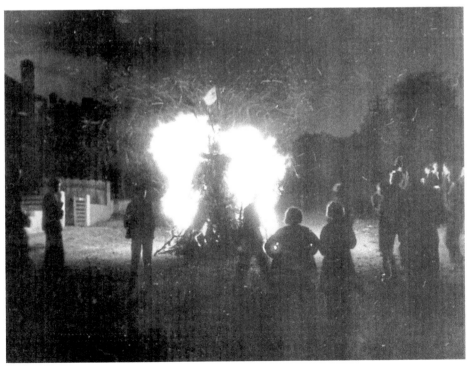

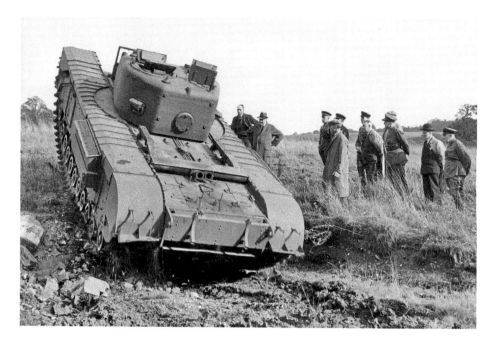

A Churchill Tank Under Test

By July 1941, the new Churchill RHF tanks were starting to roll off the Y Block production lines at Vauxhall Motors in Luton. Seen above is one of the models being put through its paces at the company's test site at Luton Hoo, watched by a Soviet delegation, some military personnel and representatives of Vauxhall Motors. Later models were road tested, travelling on a circular route up Cutenhoe Road from the factory, along Luton Road towards Harpenden and returning to the Vauxhall plant via Thrales End Lane where, for many years after the war, the impressions made by the tanks' tracks were still visible in the tarmac. Below is Thrales End Lane, at the junction with Luton Road as it appears today. This corner was known as 'Shere Mere', the county boundary with Bedfordshire.

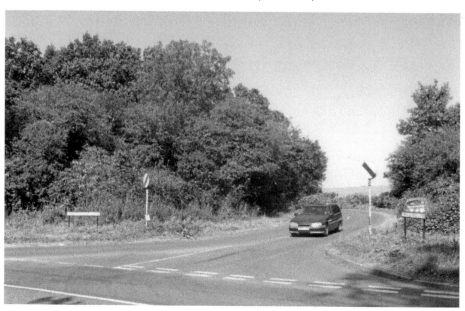

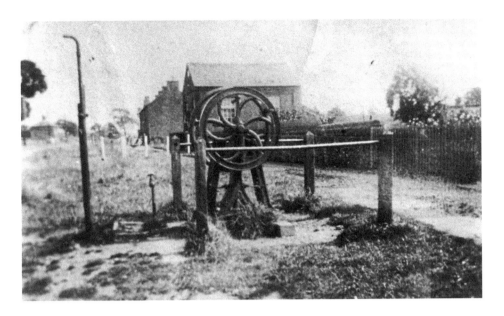

Kinsbourne Green I

Like many small hamlets, Kinsbourne Green once relied on its water supply from the communal village pump, as shown above. Although there had been a well on the site for many years, the hand-operated pump was not installed until 1905 at a cost of £90. There were two pipes from which the water could be obtained, a small standpipe for jugs and buckets and a taller pipe for water carts and wagons. The building just behind the pump is the old Methodist church, built in 1856. Another local source of water was that obtained from Annables Farm where the well there was 145 feet deep. To draw the water, a donkey walked a 13½-foot-diameter wheel, as seen in the bottom picture, taking approximately fifteen minutes to raise a full bucket containing 18 gallons. In 1900, a mechanical pump replaced the donkey, whose name was Dink, and who lived to be twenty-seven years old. Although the village pump has long gone, the old donkey-wheel still exists.

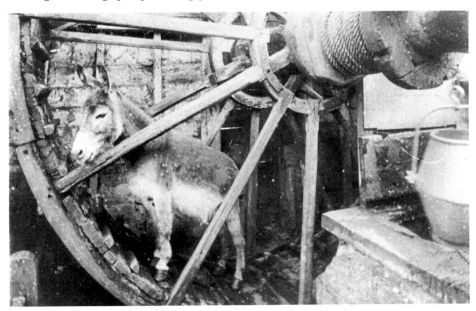

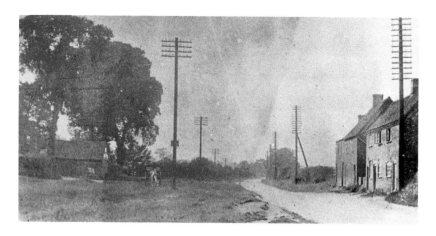

Kinsbourne Green II

Once little more than a country lane, the main road to Luton, now the A1081, at Kinsbourne Green, shows The Fox public house just visible on the left, while The Harrow, now Charlie's Restaurant & Bar, is just out of camera shot behind the photographer. The two cottages on the right have long since been demolished, while further up the road were the kennels of the Hertfordshire Hunt before their transfer to Houghton Regis in Bedfordshire just prior to the outbreak of the Second World War. Upmarket housing now occupies the site of the old kennels. A popular venue in the 1930s was the nearby Green Lawns, a small country club that attracted an elite and fashionable clientele who would motor out into the country to enjoy afternoon tea, a quiet dinner or an energetic game of tennis. Over the years with changing trends, the fortunes of the club had dwindled, becoming at one time a transport café. Today, with Kinsbourne Green a highly desirable area in which to live, the site of Green Lawns has now been developed into a prestigious residential development, once again attracting the elite and the fashionable to this lovely part of Harpenden. Although no longer the tranquil village that it used to be, the town still has considerable charm and character, and is undeniably a pretty place in which to live, work or visit, as this nostalgic glimpse of *Harpenden Through Time* will surely testify.

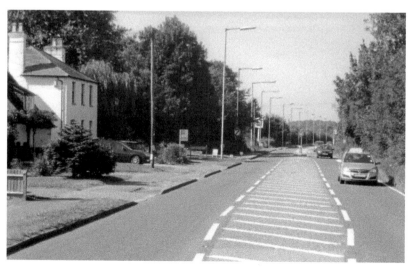